Studies in the History of Art
Published by the National Gallery of Art,
Washington

This series includes: Studies in the History of
Art, collected papers on objects in the Gallery's
collections and other art historical studies
(formerly *Report and Studies in the History of
Art*); Monograph Series I, a catalogue of stained
glass in the United States; Monograph Series II,
on conservation topics; and Symposium Papers
(formerly Symposium Series), the proceedings
of symposia sponsored by the Center for
Advanced Study in the Visual Arts at the
National Gallery of Art.

*Forthcoming

The Feast of the Gods: Conservation, Examination, and Interpretation

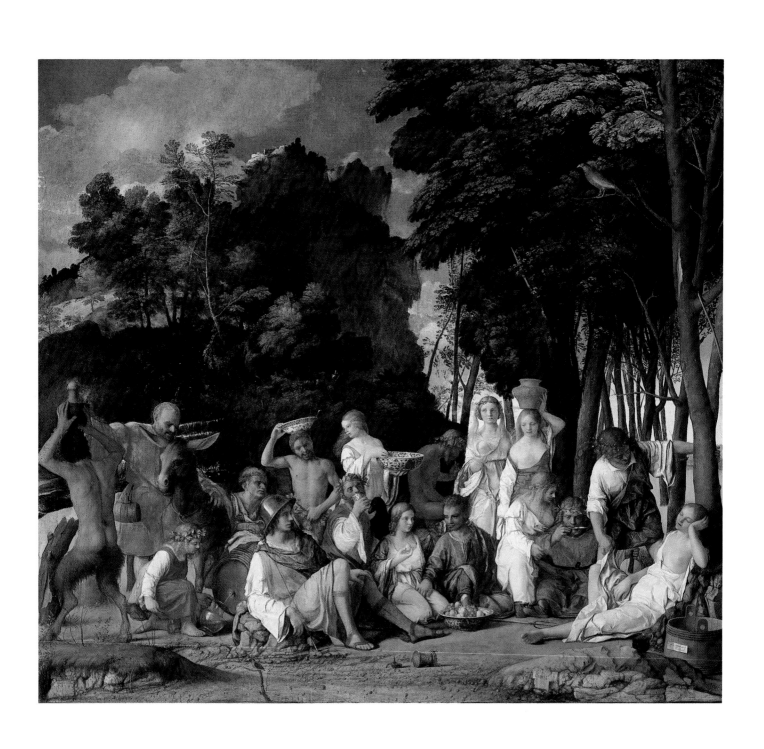

STUDIES IN THE HISTORY OF ART · 40 ·

Monograph Series II

The Feast of the Gods:
Conservation, Examination,
and Interpretation

David Bull

Joyce Plesters

National Gallery of Art, Washington

Distributed by the University Press of New England

Hanover and London

Editorial Board
DAVID A. BROWN, Chairman
DAVID BULL
NICOLAI CIKOVSKY, Jr.
HENRY A. MILLON
CHARLES S. MOFFETT

Editor
MARY YAKUSH

Designer
CHRIS VOGEL

This publication was produced by the Editors Office, National Gallery of Art, Washington.
Editor-in-chief, Frances P. Smyth
Printed by Schneidereith & Sons, Baltimore, Maryland
The text paper is 80 pound LOE Dull text with matching cover
The type is Trump Medieval, set by BG Composition, Baltimore, Maryland

SECOND PRINTING

Distributed by the University Press of New England, 17½ Lebanon Street, Hanover, New Hampshire 03755

Abstracted by RILA (International Repertory of the Literature of Art), Williamstown, Massachusetts 01267

ISSN 0091-7338
ISBN 089468-144-3

Cover: Detail, The Feast of the Gods

Frontispiece: Bellini and Titian, *The Feast of the Gods, after restoration*
National Gallery of Art, Widener Collection 1942.9.1

Contents

Foreword

In 1985 the Trustees of the National Gallery of Art authorized conservation treatment for one of the most important paintings in our collections, *The Feast of the Gods*. Signed and dated by Giovanni Bellini in 1514 and partially repainted by Titian, probably in 1529, the painting has had a long and complex history. It is compelling not only for its visual beauty, but also because of the importance of its noble patron, Alfonso d'Este, Duke of Ferrara, and the special place it occupied, literally and figuratively, in sixteenth-century Italy.

After passing through an intriguing series of private collections, this painting entered the public domain for the first time in 1942 when it came to Washington with the Widener Collection in the second year of the Gallery's existence. Installed prominently in rooms devoted to Venetian Renaissance painting, *The Feast of the Gods* has been an object of scholarly scrutiny and public admiration ever since. In 1956 John Walker, then Director of the Gallery, published an important monograph, *Bellini and Titian at Ferrara: a Study of Styles and Taste*, which made use of X-radiographs and began to unravel the mysteries of the canvas. Further research was hampered by the thick and discolored varnish that not only obscured many of the painting's splendid details but also veiled the rich color that is a hallmark of Venetian painting. When the Trustees agreed to proceed with the removal of this varnish they also authorized a thorough technical study to ascertain more about the painting's physical structure and the materials that constitute it. The results of these efforts are published here, and for their contributions we are most grateful to David Bull, the Gallery's head of paintings conservation, and to Joyce Plesters, formerly Principal Scientific Officer of our sister institution, London's National Gallery.

It seemed most appropriate to publish these findings as a volume in the Gallery's *Studies in the History of Art*, in our ongoing program of disseminating new scholarly information about works in our collection. It is our hope that readers of this volume will also see the Bellini/Titian masterpiece reinstalled in the context of our Italian Renaissance galleries, where for several months it is to be the focus of a didactic exhibition. Devoting an exhibit to a single Old Master painting is new ground for the National Gallery, one that dramatizes our commitment to the permanent collection. In addition, the Gallery has produced and is distributing a thirty-minute film about *The Feast of the Gods*, made possible by The Circle of the National Gallery of Art and Salomon Inc, in our ongoing efforts to ensure maximum accessibility to the great artistic treasures that have been secured for this nation.

J. Carter Brown
Director

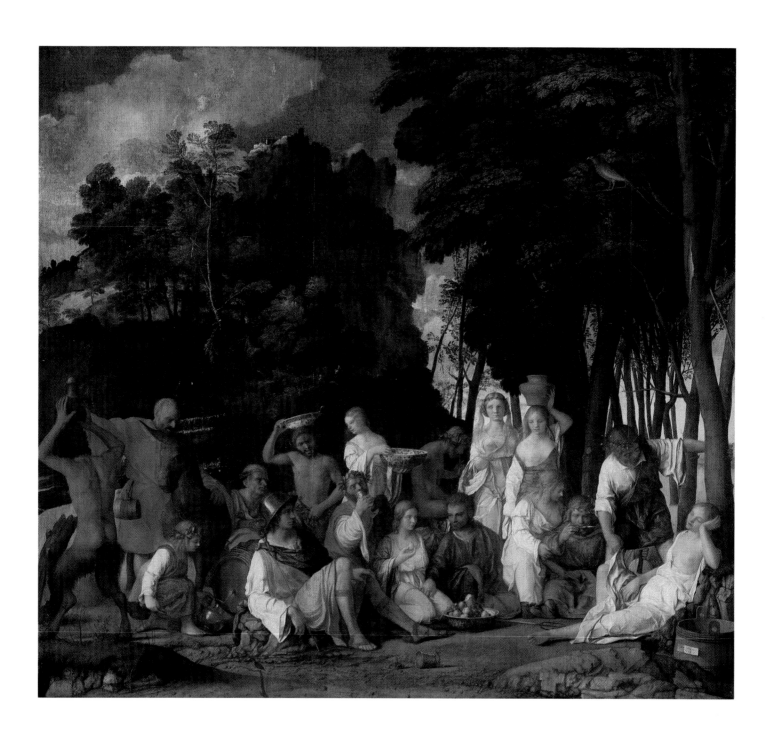

DAVID BULL

Introduction

For the Church of Santa Maria Gloriosa dei Frari, Venice, the noble Pesaro family commissioned two great altarpieces. The first was Giovanni Bellini's triptych *Madonna and Child with Saints Peter, Nicholas, Benedict, and Mark* for the Sacristy Chapel, signed and dated 1488. The second was Titian's *Pesaro Madonna*, begun in 1519 and completed in 1526. Titian's other great work for the Frari is the *Assumption*, 1518, that rises up majestically from behind the high altar.

At the National Gallery of Art, Washington, it is possible to see the work of these two great artists together in one great painting—*The Feast of the Gods*, signed and dated by Bellini in 1514 and partially repainted by Titian, probably in 1529 (fig. 1).[1] It was one of the four masterpieces created for the decoration of the private rooms of Alfonso d'Este, Duke of Ferrara, and described in a famous passage in Vasari's *Lives*[2] (1568) as "one of the most beautiful works that Giovanni Bellini ever created." Vasari also writes, "unable to carry through this painting completely because he Bellini was old, Titian was summoned, since he was better than all others so that he may bring it to completion."

When Alfonso set out to create and decorate a series of private rooms in the Via Coperta, the covered, elevated passageway linking the castle and palace in Ferrara, he attempted to bring together in one of them the work of the finest living painters in Italy. This room has come to be known as the Camerino d'Alabastro because it contained a number of bright alabaster reliefs made by Antonio Lombardo in 1508.[3] Although Alfonso's hope was not realized, he nevertheless succeeded in decorating the room with four superb Venetian paintings: Bellini's *The Feast of the Gods*, and later, over a fifteen-year span, three paintings by Titian—*The Worship of Venus* (fig. 2)[4] and *The Andrians* (fig. 3),[5] both now in the Prado, Madrid, and *Bacchus and Ariadne* (fig.4),[6] in the National Gallery, London. The scheme was completed by a *Bacchanal of Men*, frieze, and ceiling decorations (figs. 5–8),[7] all by Dosso Dossi, court painter at Ferrara.

It is not my purpose here, however, to enter into a discussion as to the exact locations of the rooms, the precise dating of the rebuilding and decoration, or the details and commissions to other painters. Rather, the essential elements of the creation of the decoration are summarized here, only in so far as they relate to *The Feast of the Gods.*

The only document[8] known that relates to *The Feast of the Gods* is a letter from Alfonso d'Este, dated 14 November 1514, authorizing a final payment to Giovanni Bellini of eighty-five golden ducats. On the *cartellino* pinned to the vat in the lower right corner of the picture are the words:

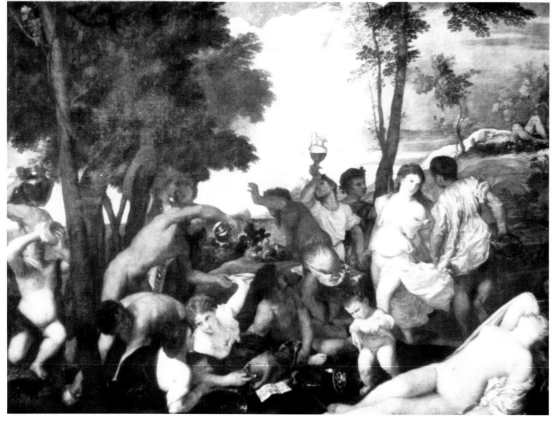

2. Titian, *The Worship of Venus*
Prado Museum, Madrid

3. Titian, *The Andrians*
Prado Museum, Madrid

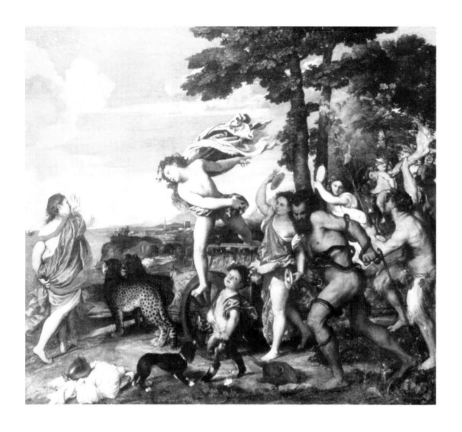

4. Titian, *Bacchus and Ariadne*
The National Gallery, London

5. Dosso Dossi, *Bacchanal of Men*
The National Gallery, London

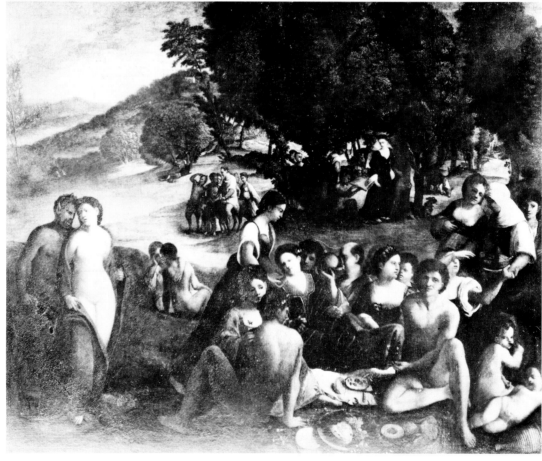

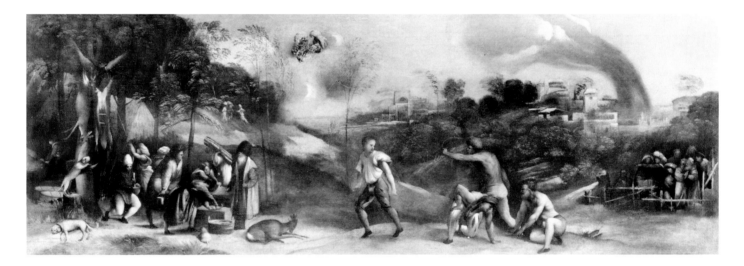

IOVANNES BELLINUS VENETUS
p. MDXIIII

Although the painting itself is not mentioned in the letter, the absence of any other work by Bellini in the duke's collection and the coincidence of the date of the painting and the final payment leave no doubt as to its purpose.

It is known that Alfonso commissioned works from both Fra Bartolommeo[9] and Raphael[10] to decorate the room, but that only drawings were completed before their respective deaths in 1517 and 1520. As the result of the failure of this part of the scheme, Titian was sent a canvas and stretcher intended for the first of his contributions, *The Worship of Venus.* A letter from Thebaldi,[11] the duke's agent in Venice, states that Titian had received the stretcher and canvas in April 1518 and had begun work. It was Titian's practice to bring a painting close to completion, send it to the intended site, and then to follow on shortly and finish the work in situ. So in 1519 *The Worship of Venus* was sent by barge from Venice to Ferrara, to be completed later by Titian.[12]

Shortly after Raphael's death in 1520, Titian received his next assignment from the duke: *Bacchus and Ariadne.*[13] Similarly, this nearly finished canvas was sent in advance to Ferrara in January 1523. The artist followed one month later, returning again to Ferrara in June 1524 and December 1524,

6. Dosso Dossi, *Aeneas in the Elysian Fields*
National Gallery of Canada, Ottawa

7. Dosso Dossi, *The Sicilian Games*
The Barber Institute, Birmingham

8. Dosso Dossi, *Aeneas and
Achates on the Libyan Coast*
National Gallery of Art, Washington,
Samuel H. Kress Collection 1939.1.250

remaining until mid-February 1525. It seems that on one of those visits he completed his last Bacchanal of *The Andrians*.[14]

Titian's final visit to Ferrara, recorded in the early part of 1529,[15] was his longest: together with four assistants, he stayed for about eleven weeks. Although no documentary evidence has ever been found to link his last and most extended visit with any known painting, it must be considered as the most probable time that he repainted *The Feast of the Gods*.

Further decoration in the Camerino d'Alabastro was carried out by the brothers Dosso and Battista Dossi who painted a frieze[16] of ten scenes depicting stories from *The Aeneid* together with ceiling decorations. Only three sections of this frieze have survived to this day, *Aeneas in the Elysian Fields*[17] (National Gallery of Canada, Ottawa), *The Sicilian Games*[18] (Barber Institute, Birmingham, England), and *Aeneas and Achates on the Libyan Coast*[19]

(National Gallery of Art, Washington). Finally, on one of the walls hung a painting by Dosso Dossi described as a *Bacchanal of Men*.

On the failure of the Este line of succession in 1598, the City of Ferrara reverted to the papacy, and consequently most of the family treasures were dispersed. Cardinal Pietro Aldobrandini took possession of the castle in the name of Pope Clement VIII and promptly dispatched the five most important paintings to Rome. These are described in a letter[20] by Annibale Roncaglia as *Bacchus and Ariadne*, *The Worship of Venus*, *The Andrians*, *The Feast of the Gods*, and a *Bacchanal of Men*. This last painting cannot now be identified with certainty, although it has been suggested that this could be the *Bacchanal of Men*[21] in the National Gallery, London.

Although *The Worship of Venus* and *The Andrians* came into the possession of Philip IV in Madrid by 1638,[22] *The Feast of the*

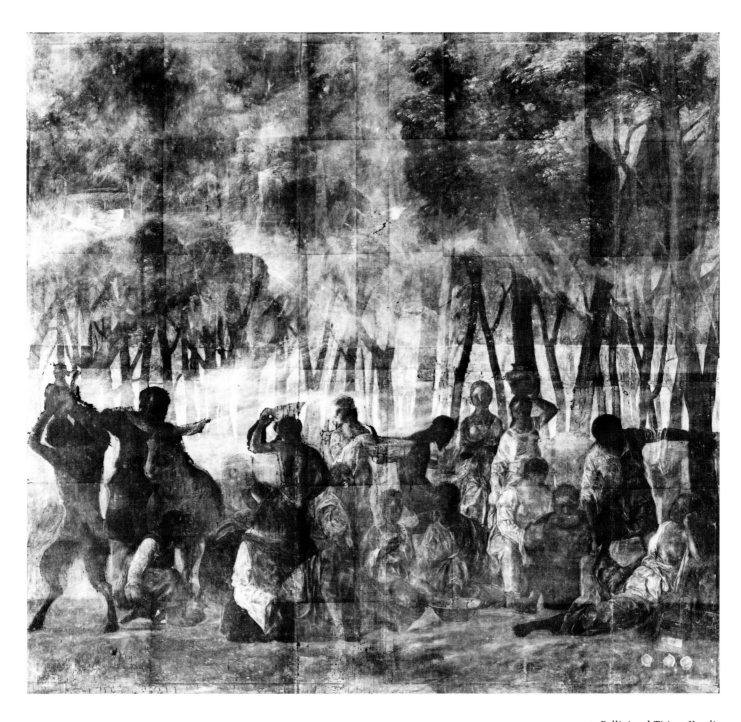

9. Bellini and Titian, *X-radiograph, The Feast of the Gods, before cleaning*
National Gallery of Art, Washington

Gods and *Bacchus and Ariadne* remained with the Aldobrandini family and their heirs until 1797.[23] At that time they were purchased by Vincenzo Camuccini and his brother. *Bacchus and Ariadne* passed from their collection in 1806 and subsequently through various hands until it entered the collection of the National Gallery, London, where it has remained since 1826.

The Feast of the Gods remained in Rome with Vincenzo Camuccini until his death in 1844. From there it went to Alnwick Castle in England in 1856, into the considerable collection of the 4th Duke of Northumberland. In 1917, when the 7th Duke of Northumberland placed the painting for sale through Thos. Agnew and Sons and Thomas Sully in London,[24] Isabella Stewart Gardner made a courageous attempt to purchase it. Although encouraged warmly by Mary and Bernard Berenson, she was unsuccessful due to the heavy burden of war taxes.[25] In 1922 Joseph Widener acquired the painting and hung it in Lynnewood Hall, Philadelphia, until it came to the National Gallery of Art, Washington, as the central star of the Widener Gift in 1942.

In 1956, John Walker, then director of the National Gallery of Art, published *Bellini and Titian at Ferrara—a Study of Styles and Taste*,[26] a book celebrating the Gallery's painting and also investigating and discussing the Camerino d'Alabastro. This publication was the first to reproduce the X-radiographs (fig. 9) of *The Feast of the Gods*, disclosing previously unknown glimpses of the original Bellini composition, that are now hidden beneath the Titian alterations. Since Vasari's *Lives*, it had been known that Titian had repainted the majority of the Bellini landscape, behind and above the figures. Walker's interpretation of the X-radiograph also revealed that Titian also made numerous changes and additions to the figures, and the surprising discovery of yet another totally unsuspected alteration to the landscape.

In 1985, the Trustees of the National Gallery of Art agreed to the proposal that the painting should undergo conservation treatment and the removal of its very thick, discolored varnish. At the same time, a technical study was undertaken to provide information on the structure and materials used throughout the painting. The conservation treatment and scientific study of the painting, and the revelations that followed, are the subject of this book.

ACKNOWLEDGMENTS

The work on the painting could not have been carried out without the support of a number of people. In particular, I wish to thank Professor Sydney J. Freedberg, chief curator emeritus of the National Gallery of Art, for his enthusiasm, encouragement, advice, and support.

Joyce Plesters' contribution, together with the support of the scientific departments of the National Gallery, London, and the National Gallery of Art, Washington, has been of the greatest value. In addition, for their work on this project, I am grateful to the staff of our departments of paintings conservation, southern Renaissance painting, education, design and installation, and external affairs, as well as the editors office, the library, and the photographic laboratory; particular thanks are due to José Naranjo for his excellent photography throughout the project.

NOTES

1. *The Feast of the Gods*, 170 x 188 cm.

2. Vasari, *Le Vite*, 2d ed., pt. 3, vol. 2 (1568), 808 (Milanesi ed., vol. 7, 1881, 433).

3. Cittadella 1868, 191, and by the same author, *Nuova antologia* 27 (1874), 582; Spitzer 1892, 4:100–102; Venturi, *L'Arte* 15 (1912), 306–309; Planiscig, *Venezianische Bildhauer der Renaissance* (Vienna, 1921), 222–225; Venturi, *Storia dell'arte italiana* (Milan, 1935), 10:397–400; Walker, *Bellini and Titian at Ferrara, a Study of Styles and Taste* (London, 1956), 35–36.

4. *The Worship of Venus*, 172 x 175 cm. The Prado, Madrid.

5. *The Andrians*, 175 x 193 cm. The Prado, Madrid.

6. *Bacchus and Ariadne*, 175 x 190 cm. National Gallery, London.

7. Walker 1956, 35, and Hope, "The Camerino d'Alabastro of Alfonso d'Este," *The Burlington Magazine* (1971).

8. Campori, *Nuova antolgia* 27, 582.

9. Walker 1956, 41; Hope 1971, 712.

10. Shearman, "Alfonso d'Este's Camerino," to be published in André Chastel's *Festschrift*.

11. Campori 1874, 586–587.

12. Campori 1874, 586–587; Venturi 1928, 107, 109; Hope 1971, 646; Goodgal, "The Camerino of Alfonso d'Este," *Art History* 1 (1978); Goodgal in Cavalli-Bjorkman 1987, 162–190; Hope 1987, 25–42; Brown in Cavalli-Bjorkman 1987, 43–56.

13. Venturi 1928, 110–117; Gould, *The Studio of Alfonso d'Este and Titian's Bacchus and Ariadne* (London, 1969), 12.

14. Campori 1874, 598; Gould 1969, 12.

15. Campori 1874, 598–600; Venturi 1928, 123; Walker 1956, 46; Hope 1971.

16. Vasari 1568, 808; Mezzetti, *Storie di Enea* (1965), 19–22, 71–84; Gibbons, *Dosso and Battista Dossi* (Princeton, 1968) 28, 167–168, 193, 214–216.

17. *Aeneas and the Elysian Fields*, 57 x 167 cm., National Gallery of Canada, Ottawa.

18. *The Sicilian Games*, 59 x 170 cm., Barber Institute, Birmingham, England.

19. *Aeneas and Achates*, 60 x 90 cm., National Gallery of Art, Washington.

20. Venturi, *La Reale Galleria Estense in Modena* (1883), 113.

21. Mezzetti 1965, 93–94; Gibbons 1968, 241–243; Gould 1969, 6.

22. Ridolfi, *Le Maraviglie dell'arte, overo le vite de gl'illustri pittori veneti, e dello stato* (Venice, 1648) 178; Boschini, *La carta del navegar pitoresco* (Venice, 1660) 25, 168–171; Walker 1956, 77.

23. Walker 1956, 78–79.

24. Walker 1956, 78–79.

25. Hadley, *The Letters of Bernard Berenson and Isabella Stewart Gardner 1887–1924* (Boston, 1987), 593–603.

26. Walker 1956.

DAVID BULL

Conservation Treatment and Interpretation

Until its removal for examination and tests in 1985, *The Feast of the Gods* hung in the center of the long north wall of Gallery 22 against the cool surface of the travertine marble. Thick, discolored, and partially opaque varnish covered the painting. The figures seemed without animation, subdued in color, and overhung by an ominously heavy, dark brown landscape. An enormous architectural mid-nineteenth-century tabernacle frame only further diminished the grandeur of this exquisite painting.

Once the painting was removed from its frame, it became apparent that the painted image did not extend entirely to the edges of the canvas. A black 1½-inch wide border surrounding the composition may have been a device that Bellini developed to create the illusion of a frame. The majority of his works were painted on panel where the frame was integrated as part of the whole construction. In other words, he usually painted with a frame already in place.

Initial solubility tests of the varnish, carried out on both the area of the black border and on the edges of the painted composition within the border, revealed that the varnish was a readily soluble natural resin, either mastic or dammar. It was immediately apparent that this black border had been totally overpainted. The thick, black paint too was very soluble, and lay in the old nail holes and crudely overlapped onto the painted composition.

A careful study then ascertained the security and stability of the paint and ground. The fine-weave, original canvas had been lined with an equally fine canvas with an aqueous adhesive. At the lower left corner of the lining canvas are three red seals (fig. 10), one with the coat of arms of Vincenzo Camuccini, who purchased the painting in 1797. This valuable discovery established that the painting had been lined either before or during Camuccini's ownership. Therefore, the present lining must be approximately 190 years old.

The canvas and lining had been attached to a fixed strainer. Consequently the painting hung with uneven, minimal tension, causing slight buckling in the upper left corner of the canvas. Both the lining canvas and its adhesive appeared to be in a remarkably plastic and sound state for their age, without any signs of cleavage in the paint and ground.

Varnish removal began in October 1985, using the solvent mixture that was established by the initial tests. The overall thickness of the varnish, built up in many layers, fully supported the documentary evidence that the painting had been "refreshed" in 1917,[1] when it was put up for sale, and in 1930.[2] Probably no attempt was made to remove the existing varnish, but the painting was simply surface-cleaned and then given another overall brushing of varnish.

It is usually very difficult to find clear demarcations between succeeding coats of varnish. The application of a natural resin varnish over an underlying layer often will soften the surface enough to create a fine bonding of the two varnishes. During the removal, it was not possible to identify with certainty the actual number of layers of varnish.

The removal of the discolored varnish not only revealed much of the extraordinary color and tonal range of the painting (fig. 11), but also disclosed that all of the figures in the foreground had been selectively toned down with overpaint. The color, thickness, and tonality of overpaint on each figure varied significantly, and so it must be assumed that this was a deliberate attempt to suppress the impact of the brilliant color range of the figures. The fact that the overpaint lay in and over the flake losses in the original paint supplied absolute proof that it had been applied at a much later date than the original.

It became obvious that during the last lining and cleaning a number of damages had occurred. Some might have been accidental, but others were caused by the deliberate action of someone attempting to explore through the top surface of the paint in order to reveal the paint lying underneath. Taking a very charitable view, one could suggest that these damages were prompted by a deep curiosity and sense of enquiry. Fortunately, the resulting loss of paint was not too severe and, as will be seen, perversely became valuable in the later investigation into the early sixteenth-century alterations.

During the varnish removal, a small area of overpaint was taken from a passage within the tree trunks, to the right of the nymph holding an earthenware bowl on her head. This revealed a view of a distant line of mountains or hills, sky, and fields (fig. 12). Small, irregular remnants of a dark, brown-green paint remained scattered across the top of this distant view. These appeared to be the remnants of a tree trunk. Fine scratch marks revealed by examination under the stereomicroscope confirmed that the brown-green paint had been scraped away.

Immediately to the right of this newly

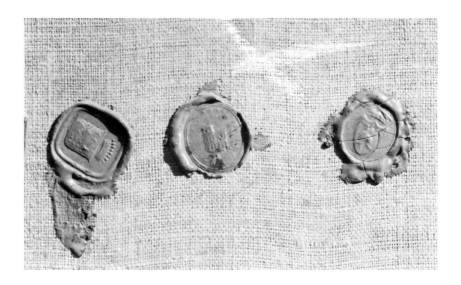

10. *Seals on the reverse of the painting*

12. *Detail, passage within tree trunks revealing distant view*

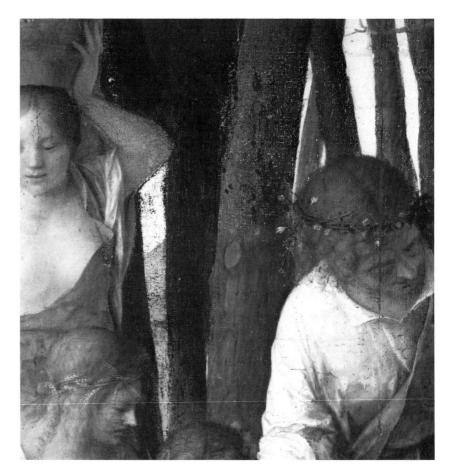

II. Bellini and Titian, *The Feast of the Gods, after cleaning and before restoration*
National Gallery of Art, Washington

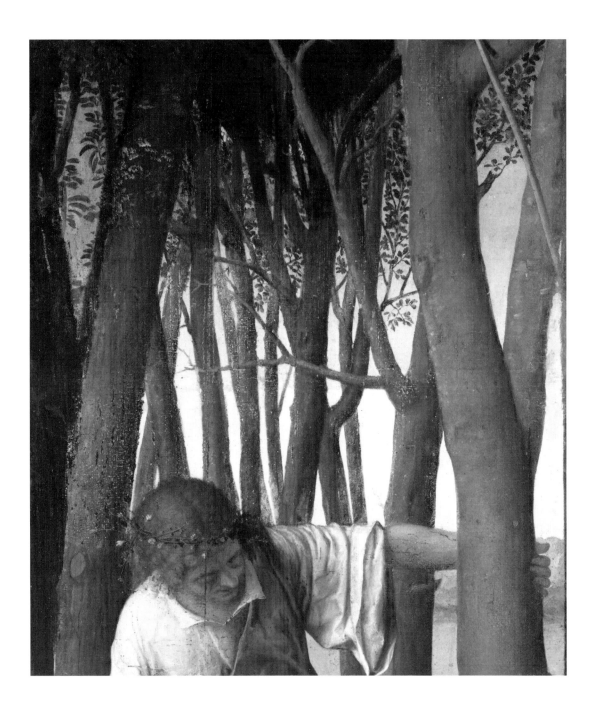

13. *Detail, trees behind Priapus*

revealed view, a group of nine trees stand behind the figure of Priapus. The bare trunks extend upward for several inches until disappearing into a mass of foliage. All of these tree trunks have been abraded in a manner that does not appear in any other part of the painting (fig. 13). In a number of other passages are found considerable fine flake losses (which will be described later), some tears, and small holes, but nowhere else can this type of abrasion be found. Judging from its appearance, the most likely cause would have been from excessive heat and pressure during lining. It seems a plausible explanation that during the lining the top layer of paint was overheated and abraded, revealing a tantalizing glimpse of the underlying paint. The excitement caused by this discovery must have encouraged a deeper probing in the one area between the tree trunks, using solvents and scraping, to investigate and reveal the brighter colored paint below.

A small tear in the canvas is present in

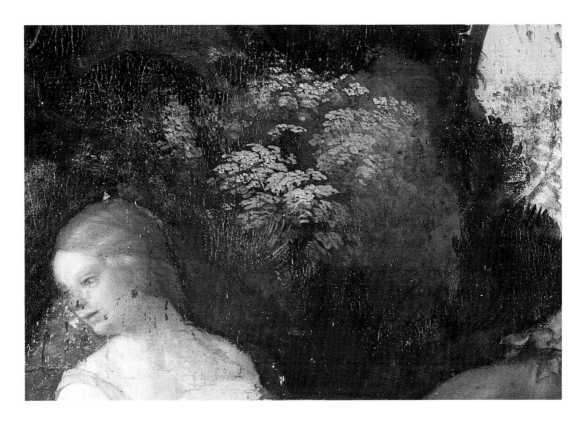

14. *Detail, middle landscape above and behind Pan's head*

the landscape of trees and bushes, just above Silenus in the middle distance. After varnish removal , it could be clearly seen that the overpaint filling the paint loss on the edges of the tear was a deep reddish-brown. The removal of this overpaint revealed bright green paint along the edges of the tear. It appears that the force of the blow that caused the tear had delaminated the paint around the edges of the torn canvas. Again, the sighting of this underlying brighter paint must have aroused considerable curiosity on the part of the "restorer."

The surface in the middle landscape above and behind Pan's head also sustained early probing (fig. 14). It must be surmised that at the time of this cleaning and lining, any number of sightings were made of this brighter paint lying just under the surface. However, in this case the glimpse of the underlying paint must have been particularly enticing to the "restorer" as it was in this area that he made his largest removal of the top layer of paint. Here it is obvious from the appearance of the edges of the remaining top paint layer surrounding this damage that a solvent had been used to penetrate and remove the paint to disclose the underlying bright green foliage. Fortu-

nately, the "restorer" realized in time that he was removing sound original paint, stopped, and proceeded to repaint the passage with the same deep reddish-brown paint used to hide other damages.

A further act of deliberate intervention affected the upper portions of the trees in the right-hand side of the landscape, where almost the entire mass of leaves and the upper portion of the tree trunks had been grossly overpainted. This had been applied thickly with the intention of "browning" the area and making the original color more subdued. The same overpaint had been carried over to some places of the landscape in the middle distance above the figures, but with a much thinner brushing. Here it seemed almost as though this area had been used to wipe out the brush used on the right-hand trees. The most surprising component of this overpaint was a liberal portion of brass powder mixed in with the other pigments. It can only be assumed that this brass was used to provide a "golden glow" popular in the nineteenth. century.

The lining canvas bears a seal on the reverse that places it in the period of Vincenzo Camuccini's ownership, therefore

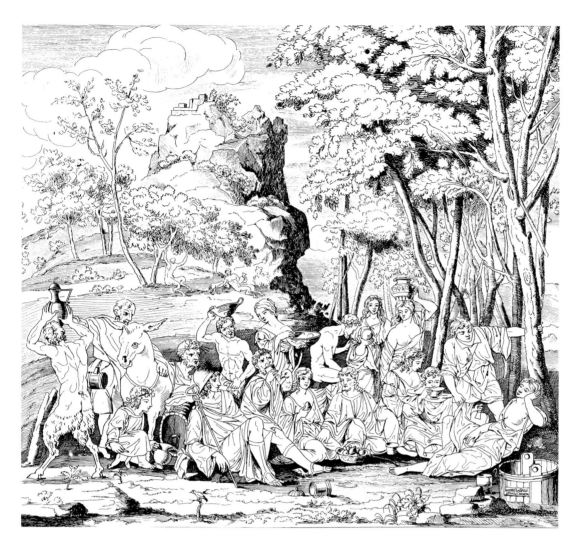

15. *The Feast of the Gods, engraving from Seroux d'Argincourt,* Histoire de l'art par les monuments, 1823

15a. Key to figures, fig. 15.
1 Satyr on extreme left;
2 Silenus; 3 Infant Bacchus;
4 Silvanus; 5 Mercury; 6 Satyr
with bowl on head; 7 Jupiter;
8 Nymph with bowl; 9 Cybele;
10 Pan; 11 Neptune; 12 Nymph
with outstretched hand;
13 Nymph with jar on head;
14 Ceres; 15 Apollo; 16 Priapus;
17 Lotis

suggesting that the harsh cleaning and gross overpainting occurred at the same time. Analysis of the overpaint medium shows that it was likely to be nineteenth-century in origin, but the most convincing evidence came from an 1823 engraving of *The Feast of the Gods* (fig. 15)

The engraving clearly shows the gap between the tree trunks to the right of the nymph with a bowl on her head, which we know was created by removing a Titian tree trunk. This confirms that the damage must have been done before the date of the engraving and so convincingly incriminates Camuccini.

Walker published a most informative photograph of the surface of the painting made in raking light. This demonstrated the remarkable difference in thickness of

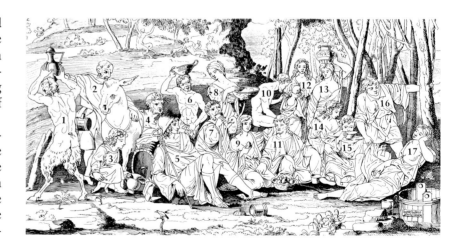

the paint between the surrounding landscape and the much thinner paint of the figures. This is particularly noticeable around the edges of the figures where the

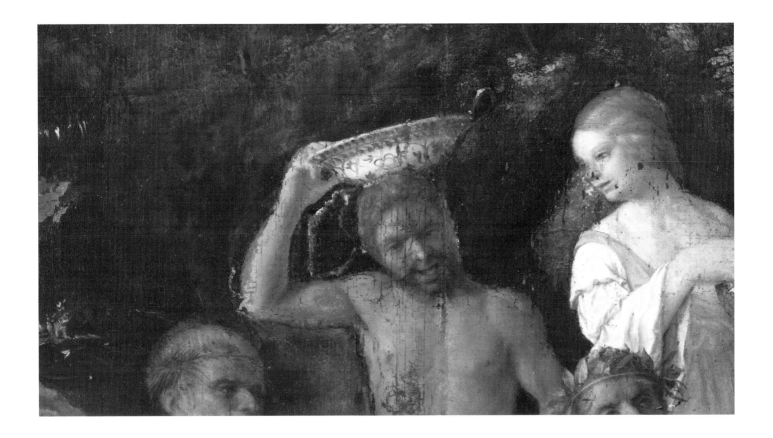

16. *Detail, Satyr with bowl*

brush, loaded with paint, left an even thicker deposit as it carefully followed the outline of the forms. In several places this "fat" edge of the landscape paint had broken away, pulling with it the first Bellini landscape, exposing wide gaps of the bare canvas (fig. 16). These gaps had been filled at some later time with a dark brown filling and overpaint. As will be seen in the following pages, the landscape has in many places been repainted twice on top of the original Bellini landscape, accounting for the considerable thickness of the paint. This added thickness and weight of the paint must have caused considerable adhesion problems for the gesso on the canvas, which could well have been aggravated at a later time by heat and pressure during the process of lining. These losses are easily identified in the X-radiograph by their total lack of density and can be seen as black lines of irregular thickness around the edges of the figures.

The most remarkable of these losses is located in the triangular area within the crooked arm of the satyr holding a bowl on his head. The losses all around the inner edges of his arm have formed a small, irregular island of thick landscape paint that appears to be suspended in mid-air.

Unfortunately, but not without surprise, the orange robe of Silenus has suffered badly from the past harsh use of solvents. The orpiment and realgar pigment mixture used to create this orange color is well known to be highly susceptible to solvents. This once-glorious orange, so typical of this period of Venetian painting, has now been lost. The highlights of the shoulders, built up with white and yellow, are now revealed without their former orange glaze. To attempt to cover over this damage, the orange robe was overpainted with oil paint. Much of the overpaint has been removed, except in a few places where it was unsafe to attempt a complete removal.

The folds of the white sleeve of Jupiter (fig. 17), so often referred to in recent literature as an obvious alteration by Titian, also proved to be covered with a later overpaint used to disguise paint loss and abrasion to the original. Again, this overpaint was found to be too insoluble to remove completely without risk to the underlying

remains of the original. Thus a thin layer of this false paint had to be left in place, partially covering the abraded original.

When the discolored varnish had been removed, it was clear that the leaves and grapes around the waist of the satyr with the blue and white bowl on his head were overpainted. These false additions were removed with solvents and it was found that not only was the original clutch of leaves around his waist in fine condition, with subtle and delightful brushwork, but also that the satyr had furry thighs. However, the major surprise was the discovery of a hand lying on Mercury's shoulder. This strange, amorphous hand is placed in such an odd position that it does not appear to belong to any of the other figures. Just as mystifying is the fact that this hand cannot be seen in the 1640 Poussin School copy (fig. 28), suggesting that it was not visible at the time the copy was made. The only plausible explanation is that Bellini originally painted in this hand, only to cover it over later while making various adjustments. Then, at some later date, after the

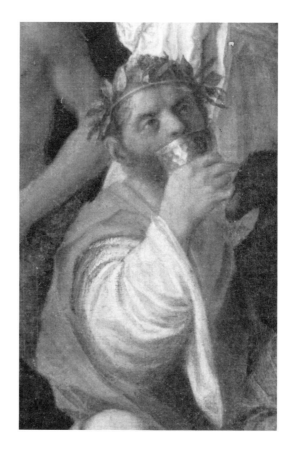

17. *Detail, Jupiter's sleeve*

18. *Detail, hand lying on Mercury's shoulder*

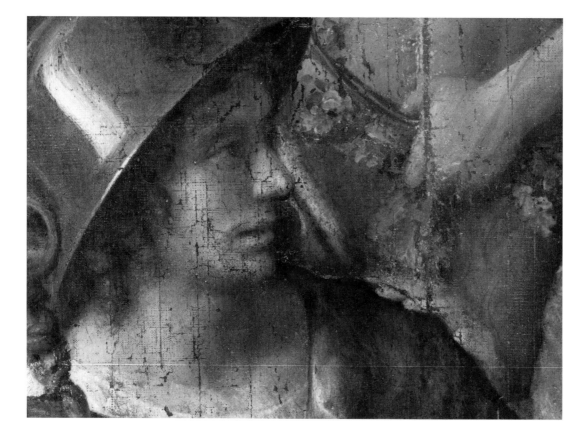

19. *Detail, Cybele*

copy was made, Bellini's own repaint was removed during a cleaning, only to be covered over again with the false leaves and grapes.

The flowing amber-colored hair of the nymph holding the blue and white porcelain bowl was concealed by overpaint, generously applied to disguise some minor paint losses. This newly revealed hair has once again become a most important part of the composition. Ovid's story of Priapus and Lotis,[3] which is the source for *The Feast of the Gods*, tells how Silenus' ass brays and wakes up the gods, who then see Priapus caught in the act of trying to ravish Lotis. The swing of the nymph's hair supplies the only display of movement within the framework of the other static figures, suggesting that her head was quickly turned at the sound of the braying ass. The angle of her hair and the pose of her body, placed in the center of the figures, neatly link the braying ass with the figures of Priapus and Lotis.

Finally, the strangely awkward arms of Cybele (fig. 19), swathed in flowing, diaph-

anous gray cloth, had been strengthened with the addition of pale gray highlights. Once removed, the position of her arms took on less prominence and their appearance seemed a little less awkward and ungainly.

Although the figures and the foreground have suffered from a considerable number of very small flake losses, it must be said that the overall condition of the painting is remarkably good for its age. Because so many of these flake losses run in a vertical direction, it is tempting to suggest that these might have been caused by the canvas having been rolled for its transportation from Venice to Ferrara in 1514. Cracks could have developed in the brittle gesso and lead priming, which later promoted the cleavage and flaking. Since none of this flaking is found in the thicker areas of the landscape, it seems quite possible that the repainting over the Bellini paint during the subsequent fifteen years prevented it from developing these faults.

No cleavage, incipient cleavage, or flaking was discovered during the varnish removal. However, the looseness of the canvas on its fixed strainer, together with the buckling in the upper left corner, caused concern. Consequently, the canvas and lining were removed from the strainer and a strip lining was attached to the edges and then restretched onto a new stretcher with expanding mitered corners.

The Feast of the Gods, signed by Giovanni Bellini and dated 1514, was radically altered twice within fifteen years. The alterations prompted an investigation to answer three main questions. First, how extensive were these alterations? Second, if we accept that it was Titian who made the final alteration, who made the first change to the Bellini composition? Third, why were these alterations made?

The conservation work enabled the painting to be seen with clarity for the first time in approximately 180 years, unveiling a sense of space, light, movement, and glorious Venetian color (fig. 11). Meanwhile, the objective analysis of the painting has provided a wealth of new information on the pigments and media, together with an

understanding of the sequence and composition of its structure. Each part of this technical analysis has been important, but the greatest contribution to our understanding has come from the juxtaposition and comparison of each piece of information. For example, the composition of a particular paint layer—its pigments and density—has become much more informative when placed in context with the reading of the X-radiograph (fig. 9) at its location. Similarly, the comparison of the images of the X-radiograph and the infrared reflectograph (figs. 20, 21) of the same location on the painting can often provide substantially more information and clarity.

In the initial examination of the painting, the X-radiograph was the only resource available that provided a glimpse of the appearance of the Bellini in 1514 and at

20. *Infrared reflectograph*

21. *Detail, fig. 20, from upper right corner*

22. Bellini, *Death of Saint Peter Martyr*
National Gallery, London

the same time showed that there had been another alteration to the Bellini landscape. It revealed that when the painting first hung in Ferrara in 1514, the figures were placed against a continuous row of trees. The tree trunks, subtly ranging in size, texture, and color, grew up and through the top of the picture, filling the upper half with lush, dense foliage. Between the trunks, the distant view of sky, mountains, and fields gave a feeling of a great space beyond the trees. Its appearance would have been reminiscent of the background trees in Bellini's *Death of Saint Peter Martyr* (fig. 22) in the National Gallery, London, painted approximately ten years

earlier. Here the scale is smaller and the closeness of the tree trunks and foliage provides a denser backdrop to the figures.

The first alteration could be seen as a group of several buildings in the upper left portion of the picture (fig. 23). They appear to be scattered about with slanting roofs, columns, a strange block of masonry lying at an angle, and perhaps even an obelisk, apparently standing on the top of a hill. They stand out quite strongly since the paint used was dense and resistant to X-rays, making them appear as light strokes of paint. The *pentimento* of one small building with a high pitched roof can be spotted on the painting itself, just showing through the thin layer of blue sky that once covered it.

At the initial stage of the investigation, it was assumed that these buildings standing on a hill were the extent of the first alteration. The complexity of the X-radiograph, presenting simultaneous information from all of the painting structure, did not allow a clear, recognizable image of any other part of this alteration if, indeed, it did extend beyond the cluster of buildings. Many passages of the X-radiograph were puzzling and hard to decipher.

Strong, sweeping brushstrokes of dense paint appear to lie directly behind and around the figures at the left of the com-

position. At first glance they seemed to portray a path winding around the base and then climbing up the side of the hill on which the buildings stand, but it was not possible to tell their position within the paint structure. Only the cross sections could be capable of showing whether these layers of paint belonged to part of the Bellini composition, the first alteration, the final repainting by Titian or, even, that they could possibly be some part of the lining adhesive.

Another curious area was seen in the large trees on the right-hand side. A dense passage appears to swirl within and between the lower branches of the trees, almost as though a thin cloth has been draped through the trees and branches. No explanation of this could be found on the surface of the painting, nor did it seem to bear any relationship to the original Bellini composition. Yet a further incomprehensible area of density could be seen as a strong, horizontal passage in the right half of the painting, defined by a firm, straight upper horizontal edge above, between, and around the figures and tree trunks. This, also, did not appear to correspond to any of the surface image, and, therefore, would be a part of the painting's structure at a lower stage.

It was assumed that the buildings, and possibly the hill on which they stood, represented the full extent of the alteration to the painting. During the early days of the investigation, only a few cross sections were taken from the edges and were studied with the preconception that the buildings on the hill represented the entire alteration and the remainder of the landscape had only been repainted once.

The varnish and overpaint removal exposed the passages that had been harshly cleaned by Camuccini in the nineteenth century and revealed underlying bright green foliage (fig. 14). It was only at this moment that the full extent of the first alteration was realized. With the green foliage immediately visible to the naked eye, its presence became more obviously discernible in the X-radiograph.

Confirmation of the greater extent of the alteration came with the examination of the infrared reflectograph, which until this mo-

23. *Detail, X-radiograph, The Feast of the Gods*

ment had not been found to be particularly informative, other than giving another, less clear, image of the original Bellini composition. The distinctive formation of the bright green foliage, once it had been clearly seen on the painting and the X-radiograph, could be sighted more easily within the gray mass of the infrared reflectograph (fig. 20).

This realization makes the complicated and confusing layering within the cross sections more comprehensible. In the area of the landscape above the figures the presence of two overall passages of repainting should be expected lying above the original Bellini paint. The task of unraveling these alterations or stages in the cross sections would have been easier had an overall layer of varnish been applied between each stage. This varnish would have been visible in the cross sections, providing an identifiable junction between Bellini and the first alteration. Similarly, a coat of varnish applied overall over the first alteration would have defined the junction between this and the subsequent stage.

It must be said that the whole vexed question of the use of varnish as a surface coating by painters has yet to be satisfactorily resolved. Published recipes for varnishes supply proof that they were readily available to painters long before the early

sixteenth century.[4] However, its use seems to be more concerned with the grinding and application of colors to make paint rather than with making a clear surface coating. The practice of applying an overall coat of varnish is seldom fully described as a normal studio procedure, though it does seem to have been a method for enriching certain selected colors.

In the early sixteenth century painters were very proficient in their use and control of oil paint. They had a highly developed knowledge and familiarity with their materials and so were capable of bringing a painting to a desired degree of surface finish. Normally, a coat of varnish would be applied only at a later time, and then often by another hand, when the glossy surface of the paint had become matte through the drying and sinking of the oil. Occasionally mention is made of varnish being employed to protect a painting from the ravages of time. A Paduan manuscript[5] of the late sixteenth century contains a somewhat frightening section devoted to recipes and directions for the treatment of oil paintings that have begun to show signs of age. It consisted of washing the surface with a corrosive liquid and then varnishing with mastic resin dissolved in nut or linseed oil!

Two possibilities existed for finding an identifiable junction between alterations. The first came from the knowledge that a painter, as part of his normal working practice, would commonly "oil out" any particular passage where the oil had sunk and the surface had consequently become dull. By rubbing in a very thin amount of oil, the painter could regain the loss of color and tone. Sometimes, this method could leave a small deposit of oil on the surface, which might then be observed with ultraviolet fluorescence in a cross section. Second was the possibility of seeing a varnish of a much later date that had flowed into a crack in the surface of the paint, and then seeped further into any junction or break between the paint layers. It must be assumed that the top layer of Bellini paint had dried before the first alteration took place. Similarly, the top layer of the first alteration would also have dried before the final alteration. Consequently, a weak bond may be indicated between the surface of the dried paint and the first layer of the alteration. Aging, movement, and climatic changes might be expected to weaken further some of these fragile bonds and create a fine fissure or junction between these paint layers. Possibly centuries later, when a varnish was brushed over the surface, some of it might seep through the wider craquelure to find its way into some of these junctions.

In Joyce Plesters' essay in this volume, the location and significance of these discovered junctions have been described in detail and the pigments used throughout all the stages of the painting identified. However, the identification of these pigments alone proves to be of little value to the interpretation of the results of the investigation. All of the pigments in *The Feast of the Gods* were equally available to any painter working in Italy in the early sixteenth century. Nevertheless, the selection of pigments for their respective hue, opacity, or transparency can be of some assistance in the search for the identity of the painters of the alterations. Each painter had recognizable, personal preferences for certain colors, mixtures of colors, brushwork, use of thick or thin paint, and scumbles or glazes. The proportion of medium to pigment, choice of medium, and certain idiosyncrasies in the brushwork all become part of the "handwriting" or style of a painter. All of this is not only observed with the naked eye but also can be discerned more closely under high magnification through a stereomicroscope on the surface or within the structure through cross sections.

The compilation of all the information from the X-radiograph, infrared reflectograph, and cross sections revealed that the first alteration extended far beyond the buildings on the hill. In fact, the original Bellini landscape behind the figures was almost entirely repainted. Only the following portions of Bellini's original landscape were left intact: (1) The large tree trunk on the extreme right, reaching up to the top edge of the painting, is entirely by Bellini's hand, except for some small surface touches by Titian on the bottom of the trunk. (2) Moving away from this toward

the center of the composition, the next ten trunks are Bellini's. No evidence has been found to suggest that his sky between the trunks was repainted at this stage, nor was there any alteration to the figures or fore-ground (fig. 11).

It has generally been accepted that Ti-tian made the final alterations to *The Feast of the Gods.* The earliest mention of this comes in Vasari's *Lives*[6] of 1568 and has been the subject of much subsequent writ-ing. When the Este family lost control of Ferrara to Pope Clement VIII in 1598, Car-dinal Pietro Aldobrandini took possession of the main pictures from the Camerino and dispatched them to Rome. In a letter from Annibale Roncaglia to Cesare d'Este[7] recounting the removal of the paintings, one is described as "a painting by Bellini with a landscape by Titian." Curiously, no document has been found in the Este ar-chives that makes any mention of Titian's repainting, or, for that matter, the previ-ously discussed first alteration to the land-scape. In *Bellini and Titian at Ferrara,*[8] Walker speculates that Titian had not only repainted the landscape, but had also made seventeen changes or additions to the fig-ures. As this latter possibility has also been accepted by many scholars,[9] and has been the subject of considerable interest, it was made a specific part of the investigation.

The possible changes made to the figures in the second alteration were examined through X-radiographs, infrared reflecto-graphs, and cross sections. One great ad-vantage was obvious in this part of the in-vestigation. The figures were all lying on the top surface of the painting, thus totally visible to the naked eye, and therefore al-lowed close scrutiny with a stereomicro-scope. This made it possible to make a detailed study of the sequences of the ap-plication of the paint.

When brushing in a passage, a painter is almost certain to overlap slightly onto some of the edges of an existing area of paint. It would take a deliberate act of ex-treme and unnecessary precision not to do so. So the obvious indication of one layer of paint overlapping the edge of another clearly establishes the order or progression of the work. With this in mind, every edge between adjacent passages was examined

through a stereomicroscope. For this to be of real significance, it was necessary to identify positively Bellini's paint. Once this could be ascertained, it followed that any paint lying under the edge of Bellini paint must also have been painted by him. The search began to identify and establish benchmarks that could be attributed with certainty to Bellini.

Cross sections of the pigment mixture that Bellini used to create his tree trunks were positively identified. The low density of these trunks in the X-radiograph indi-cates that he left these passages mostly in reserve while laying in the denser paint of the adjacent sky. The tree trunks were then brushed directly on the gesso and priming into these reserved passages using a mix-ture of vermilion, black, and a small amount of white lead. It was applied very thinly with consequently low density. Ex-amination of the cross section T7 taken from the large tree trunk above Priapus clearly shows this thin layer lying directly on top of the gesso and priming. Likewise, this readily identifiable pigment mixture could be found in cross sections T3, T8, T16, and T19a. After this and other bench-marks had been established, the search be-gan of each overlapping edge to establish the sequence of painting.

On the completion of this search, it was concluded that the figures and their vari-ous accessories had all been painted by Bellini. The only alterations by another hand were two minute adjustments by Ti-tian: the addition of a handle to the blue and white bowl the satyr holds (fig. 16), and a fine adjustment to the upper edge of Priapus' arm and sleeve (fig. 13). The han-dle of the satyr's bowl can be seen quite distinctly, even with the naked eye, lying on top of the thickly painted landscape be-hind the figures. The slight repainting to Priapus appears to have been a necessary modification following Titian's repainting of Bellini's sky. Possibly Titian's sky paint had just overlapped Priapus' arm and upset the form of the arm and sleeve. It was cer-tainly not an attempt to make a radical change.

Walker's hypothesis had been based largely on his reading of the X-radiograph together with his observation of the paint-

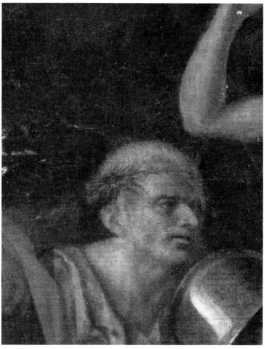

24. *Detail, Sylvanus' head*

25. *Detail, Priapus' tunic*

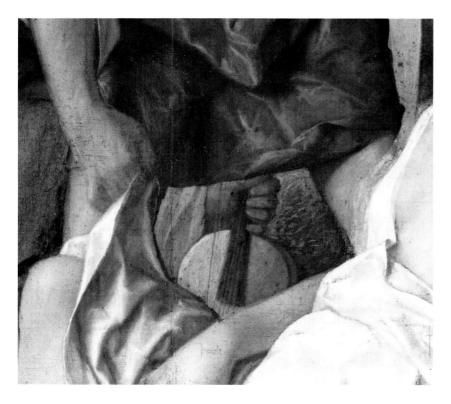

not change his mind and make anything other than minor adjustments to his own composition. From this it followed that any alterations to the figures or trees must have been made by Titian. Studies of many Bellini paintings in recent years have demonstrated that he frequently made modifications and adjustments to many parts of his own compositions. These usually resulted in a change to the position of a figure, arm, or object, rather than a large-scale reworking of an area. The X-radiograph certainly indicates any number of adjustments to the figures, with a shift in the angle of a leg or arm, and the lowering of a dress to expose more flesh, but all of these are on a minor scale. They are all perfectly in accord with Bellini's known methods of working.

Walker also incorrectly assumed that any passages visible on the painting, but not clearly defined on the X-radiograph, must denote additions by Titian. From this he deduced that the head of Sylvanus, the eagle and the *lira da braccio* clutched by Apollo were later additions by Titian.[10] Sylvanus' head (fig. 24) was painted with pigments of low density directly on top of the green grass in the foreground. Bellini did not leave a space in reserve for his head in his first placement of the main areas of the composition. In consequence, the higher density of the lead tin yellow pigment used to paint the grass prevents a clear reading of the shape of Sylvanus' head. It is interesting to note that Bellini also painted a tree trunk in the part of the space now filled by Sylvanus' head. This dark patch can be seen through part of his head, while the green grass lies under the left side of his neck and shoulder. Similarly, the eagle is painted with a thin paint directly on the ground and consequently does not appear on the X-radiograph.

The triangular passage between Priapus' sturdy thighs and Lotis' gentle arm is particularly intriguing (fig. 25). Here we see Apollo's hand suggestively grasping the *lira da braccio* as it pokes up and under Priapus' tunic against a background of lush green grass. The texture of the paint in the area of the *lira da braccio* looks quite different, much thicker than that of its surroundings. The evidence shows conclusively that this area had all been painted by Bellini.

ing. Unfortunately, at this time the painting was so much obscured by the discolored varnish and nineteenth-century overpaint that it was virtually impossible to have a clear view of the actual surface of the paint. Apparently Walker assumed that Bellini did

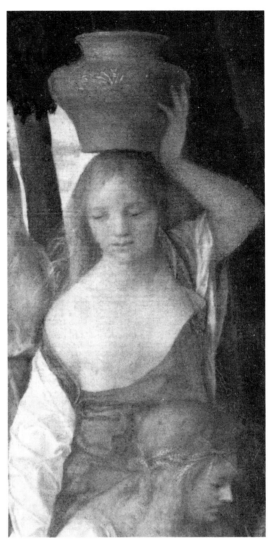

26. *Detail, Cybele and Neptune*

27. *Detail, Blue dress of nymph*

The most rewarding and straightforward discovery came from the observation that the lower edge of Priapus' tunic of brilliant changeant green and red cloth was painted over the textured grass and Apollo's hand. Since there can be no doubt of Bellini's authorship of Priapus and his tunic, here was absolute proof that the paint lying below must have been painted by the same person.

Some mention deserves to be made of three other places that had been thought to have sustained alterations:[11] the hand of Neptune (fig. 25), the blue dress of the nymph holding an earthenware jar on her head (fig. 27), and the attributes of the Gods (fig. 11). Although it has often been proposed that Titian moved Neptune's hand onto Cybele's thigh to eroticize the story, observation under the stereomicroscope confirms that Bellini painted the hand and arm and always intended them to be there. If Titian had painted in the hand, it would have been added over the yellow pink dress on Cybele's thigh. Instead, Bellini left an unpainted gap in reserve on her thigh, fully knowing that he would add the hand at a later time. Under a stereomicroscope, one can see the thinly painted flesh of Neptune's hand lying directly on the priming.

The blue dress of the nymph holding the earthenware jar on her head, which has been lowered to expose her right breast, was originally placed high up on her chest with a simple, rounder neckline. The image of the earlier dress can be seen clearly in the X-radiograph and even on the painting itself, with the *pentimento* of the blue of her first dress showing through the overlying flesh. In the copy of *The Feast of the Gods* painted by a follower of Poussin about 120 years after the original (fig. 28), this *pentimento* of the blue dress was faithfully copied. Again, Titian has been incorrectly accused of lowering the neckline of the dress for increased erotic effect. Compared with the reading from the X-radiograph, the cross sections taken from the nymph's chest amply confirm the al-

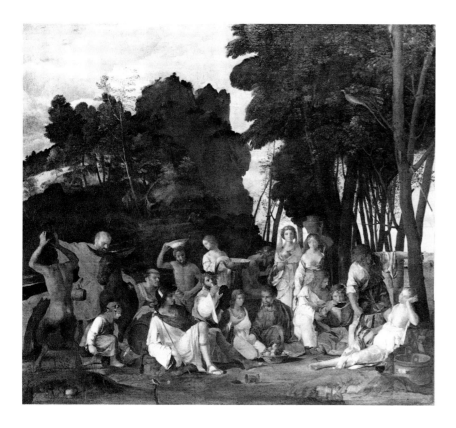

28. Poussin School, *The Feast of the Gods*
The National Gallery of Scotland

teration. In cross sections F1 and F2 there are four layers of blue paint, each of slightly different pigment composition. However, under these blue layers is the distinctive paint of a Bellini tree trunk, whose presence is also confirmed by examination of the X-radiograph. This indicates that Bellini started the composition with a tree in this position, then changed his mind to paint the nymph over the lower portion of the trunk. Examination and comparison of the layers of blue paint confirmed that the changes had all been made by Bellini. Nevertheless, one final discovery left no room for doubt. The little figure of Bacchus, kneeling down to fill a jug from the barrel, wears a blue tunic, which is undoubtedly painted by Bellini. Cross section F23 shows the two layers of blue paint. First the thicker underpaint composed of ultramarine blue mixed with white lead was laid in to create the shape and form. It was then followed with a thin glaze of pure, thin ultramarine, giving the figure its gloriously vibrant color. When this glaze was still wet, Bellini deliberately dabbed all over the surface of the tunic with his fingers, leaving a mass of fingerprints. This technique was very

common among Bellini, Cima, and many other painters of the fifteenth century as a method of breaking the surface of the paint to soften it and create a slight texture. Titian also used his fingers, but in a totally different way. The seventeenth-century writer Boschini was given a graphic account of Titian's methods by his pupil Palma Giovane. At the end of a long description he says, "It is true to say that in the last stages he painted more with his fingers than his brushes." The blue dress of the nymph, slightly lighter in color and tone than the blue of Bacchus, has the same dabbing of fingerprints as can be seen on Bacchus.

The assumption that the attributes of the gods (including Jupiter's eagle, discussed earlier) also were later additions by Titian appears to have developed from the misunderstanding of the X-radiographs, in which their presence can scarcely be detected owing to their low density. Mercury's caduceus and Neptune's trident have been painted last in the sequence of layers. This was entirely consistent with Bellini's technique of painting in the main figures and larger forms first and then finally putting the finer details in their places. In consequence, the paint of the details would be less thick and lower in density.

The last examination of the painting concerns Titian's alteration to the landscape behind and above the figures and the foreground (fig. 11). There seems no doubt that the entire left-hand portion of the landscape up to the foliage of the trees on the right-hand side was repainted by Titian. The effects of aging and some past cleaning have contributed to our being able to see the *pentimenti* of the buildings and trees that belong to the first alteration, emerging through the thin covering of paint added by Titian.

The massive trees and sky on the right-hand side present a more complicated problem (fig. 29). The earlier discussion of the conservation treatment described the damages to the trees above Priapus and the deliberate removal of a portion of the Titian tree to the right of the nymph with the earthenware bowl on her head. These and other damages were overpainted in the nineteenth century and the entire area of

the foliage and tree trunks covered with a thick, amber-colored glazing containing pigment and brass powder. The discovery of this vast expanse of overpaint on the trees led to a suspicion that there could have been more paint losses to the area than those found in the localized passage between Priapus and the nymph.

A further search disclosed another loss to the Titian paint. The tree just adjacent to the elbow of the nymph with the earthenware bowl extends upward slowly, curving toward the center of the canvas (fig. 30). Above the nymph's head a branch angles away from the main trunk. Here a particularly thick layer of the brass-laden overpaint was found to be covering over a gray branch dissimilar in brushwork and color from the adjacent paint. This branch is a part of the first alteration to the Bellini landscape.

Scattered throughout the foliage, between and under the Titian leaves and branches, are glimpses of the bright green foliage belonging to the first alteration. They raise the question as to whether they can now be seen because the Titian paint was harshly cleaned, or because they were left by Titian. If the latter was the case, did Titian integrate these brighter leaves into his own foliage intentionally, or was it that he simply did not bother to cover and obliterate every part of this paint? Of course, the answer to these questions inevitably involves the authorship of the first alteration. If Titian had painted the first alteration, there would have been no reason for him to cover up his own work completely when repainting the area.

The question of the identity of the painter of the first alteration becomes even more intriguing with two further revelations. First, in the upper right corner the large branches covered with bright green foliage, extending behind and to the left of the largest tree on the right, belong to the first alteration, not to the final Titian repainting. Second, the pheasant also belongs to the first alteration.

The first discovery came largely through the disclosure of the large damage in the landscape above Pan (fig. 13), where Camuccini's removal of the Titian paint allowed a clear view of the first alteration.

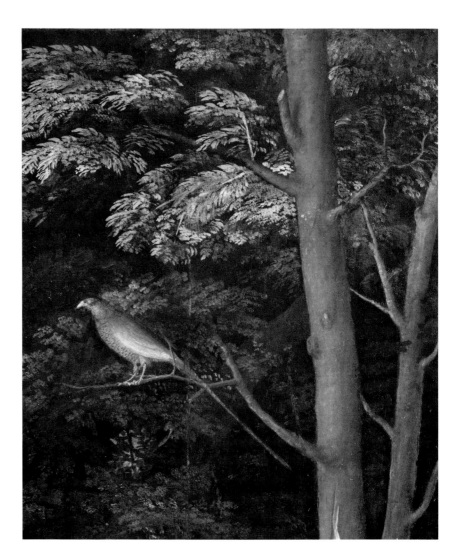

29. Detail, Foliage, upper right

Further comparisons with the other foliage of this alteration were made with the infrared reflectograph. The distinctive color and brushwork used to form the leaves, and the formation of the branches and leaves, were all found to be identical to those in the area in the upper right corner. Here again, we must ask the same question. Did Titian leave this large passage of foliage deliberately, or was it revealed in the same harsh cleaning used in the landscape above Pan? In contrast to the area above Pan, no tell-tale signs can be found to indicate that a strong solvent had been used to remove an overlying layer of paint. It would have been very difficult to remove any Titian paint without leaving a distinct edge between one layer and another. This strongly suggests that the passage in the upper right corner was never covered by Titian paint.

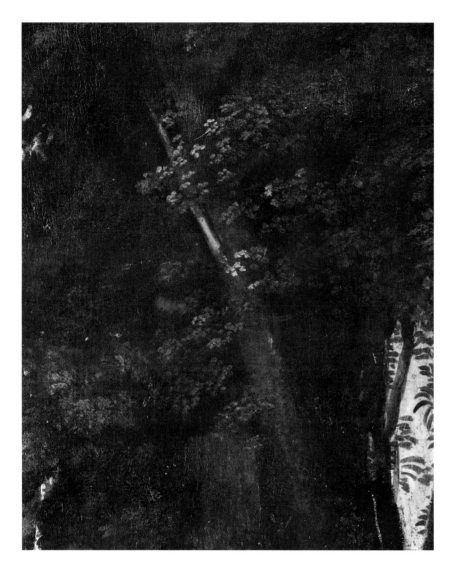

30. Detail, Branch of tree

cation that the upper paint had been applied considerably later than the cracked paint below. A sample of the yellow-brown paint taken for medium analysis was found to contain egg yolk. As the medium throughout the sixteenth-century passages of the painting has been firmly established to be walnut oil, the presence of egg yolk adds cause for further suspicion as to the age of the leaves. It also suggests a typical nineteenth-century restorer's retouching method of using oil or resinous glazes over an egg tempera.

So far, the evidence strongly suggests that Camuccini was the painter of the brown leaves. Yet the problem occurs that the very same leaves are quite apparent in the 1640 copy of *The Feast of the Gods* (fig. 28), which is a very faithful replica of the original. Their presence in the copy must mean that these leaves were in the original painting. If the present leaves are by Camuccini, the original leaves must have been removed after the 1640 copy had been made, and he must have had access to the copy in order to recreate them so accurately.

Further confusion was added when an analysis of the pigments contained in these yellow-brown leaves yielded the discovery that approximately half of the sample was found to contain lead tin yellow—a pigment that ceased to be produced and used after the mid-eighteenth century. Here, we must entertain the possibility that Camuccini might well have had in his studio a collection of older pigments, among them the lead tin yellow. For the moment, the brown leaves will have to remain, not only on the painting itself since their firm authorship cannot be established, but also as one of the parts of the investigation for which no satisfactory conclusions can be offered.

The second revelation confirms that the pheasant was in place before Titian's alteration. A raking light across the surface of a painting presents an image of the surface texture of the paint, mountains and valleys, and any variations in surface levels. This light, projected across the surface around the pheasant sitting in the trees, discloses that the paint surface of the bird is below that of the surrounding mass of foliage. It also shows a continuous ridge of

Yet another intriguing element remains. Yellow-brown leaves are scattered over the tops and edges of the large, leafy branches. Under magnification, the texture of the paint is very coarse and granular, markedly dissimilar to the sleeker, fatter green leaves below. Their brushwork is less confident and direct than any of the surrounding paint, giving the appearance of not belonging to the structure and growth of the painting. The most likely explanation is that the yellow-brown leaves were the work of a restorer working much later than the sixteenth century. Some confirmation of this came from the sighting, through the stereomicroscope, of a number of places where the yellow-brown paint could be seen lying in the cracks of the underlying green paint. This is a very common indi-

paint running around the main shape of the bird formed by paint being brushed around this shape, leaving a fat edge from the paint flowing out of the side of the brush. Examination through the stereo-microscope confirmed that the paint of the pheasant was an integral part of the paint of the first alteration to the landscape.

Thus, we must accept that Titian quite deliberately chose to leave in place both the pheasant and the branches covered in bright green foliage in the upper right corner. Therefore the figures, foreground, and most of the tree trunks in the right side are by Bellini; the landscape, sky, and majority of the foliage on the right side by Titian; and the upper right corner of bright green leaves and the pheasant belong to the first alteration.

In 1529, Titian was just completing one of his most celebrated works, *The Death of Saint Peter Martyr* for the Church of Santi Giovanni e Paolo, and had undoubtedly established himself as the leading and most innovative painter in Venice. If the first alteration to *The Feast of the Gods* had been made by another painter, it does

seem extraordinary that Titian would have left not only Bellini's tree trunks, but also two passages of painting by yet another painter.

The pheasant sitting stiffly in a lifeless pose seems markedly inconsistent with the exuberance and fluency of the surrounding brushwork. In direct contrast, the plump, richly feathered guinea fowl in the trees of Titian's *Andrians* (fig. 3) appears to be very much alive, with its bulk weighing down the branch on which it perches. It does not seem plausible that Titian could have painted both these birds within such a close period of time. Further, the brushwork and formation of the clump of bright green leaves is totally dissimilar to the surrounding foliage. Titian's trees are painted with such fluency and boldness, but are nevertheless based on his very accurate observation and understanding of their growth and formation. In contrast, the bright green leaves and branches have no sense of organic growth, but are mannered and lifeless, inconsistent with the rest of the Titian alteration.

All of this mounting evidence seems to

31. Dosso Dossi, *Infrared reflectograph of fig.* 8

32. *Detail of fig.* 31

33. *Detail*, Dosso Dossi,
Circe and Her Lovers
National Gallery of Art, Washington,
Samuel H. Kress Collection 1943.4.49

indicate the presence of another, third hand. Comparative studies made between the trees and shrubs in part of the Dosso Dossi frieze (fig. 8) that once adorned the Camerino d'Alabastro, now in the National Gallery of Art, Washington, with the bright green foliage in *The Feast of the Gods* (fig. 11) revealed remarkable similarity in the color range and appearance of the

paint, brushwork, and formation of the leaves.

Further comparisons made with another section of the frieze, *Aeneas and the Elysian Fields* (fig. 6; National Gallery of Canada) and several other works by Dosso all confirmed the intitial observations. The images from the infrared reflectographs and the X-radiographs of other works by Dosso were then compared with those of *The Feast of the Gods*. There was no doubt that the leaves and trees of the first alteration of *The Feast of the Gods*, when seen in infrared reflectographs, were identical with those found in several other Dosso paintings.

During a colloquy held on *The Feast of the Gods* by the Center for Advanced Study in the Visual Arts and the National Gallery of Art in March 1989, detailed photographs (fig. 31) of the infrared reflectographs of the foliage from the Dosso frieze (fig. 32) were passed to the participants. They were described as foliage by·the painter of the first alteration to *The Feast of the Gods*. They were accepted by the participants without question.

Comparisons of brushwork and paint were made between the pheasant in *The Feast of the Gods* and the small white dove sitting in the trees of *Circe and Her Lovers* (fig. 33) also by Dosso Dossi (National Gallery of Art, Washington). The date of this painting is uncertain, but is probably not the same period as Dosso's frieze for the Camerino. Nevertheless, a striking similarity is found in the paint application of the two birds. Apparently, the wooden end of a brush was used to describe certain marks that appear both on the feet of the pheasant and the neck of the dove.

The conclusion of all the evidence is that Dosso Dossi was responsible for making the first alteration to the landscape of *The Feast of the Gods*. Some years later, Titian must have repainted most of the Dosso landscape, leaving two small areas by Dosso's hand. The question still remains: Why was the Bellini repainted twice within fifteen years?

Vasari's statement, quoted earlier, that Bellini failed to complete the work, is of considerable significance. If it were the case, it would provide a perfectly understandable explanation for the first repaint-

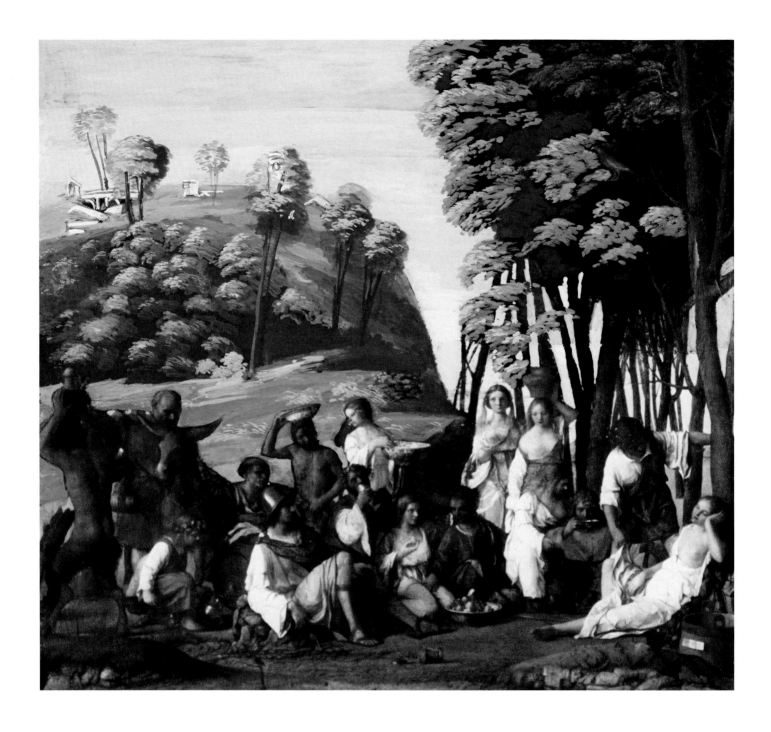

ing by Dosso, who was readily at hand because he had been commissioned to create other friezes for the duke, and an obvious candidate to finish the work. Although Vasari's statement has been believed by many writers, the evidence of the signature and date, together with a final payment of eighty-four golden ducats to Giovanni Bellini on 29 November 1514, surely makes it improbable that the painting was not completed. An exhaustive search was made of the painting to discover any possible indications that it might have remained unfinished. No such evidence was found.

Vasari frequently used the word *opera* to mean work as well as picture, and in this case, he was referring to the work of the decoration of the room, not the painting. Also, it would be most unlikely for him to describe the picture as being unfinished,

34. *The Feast of the Gods, author's reconstruction after first alteration*

when only shortly before he had called it one of the most beautiful works that Giovanni Bellini ever created.

Perhaps Alfonso had requested that Dosso should repaint the Bellini at some time following Bellini's death in 1514, before Titian became so deeply involved in the completion of the decoration. Dosso was the court painter[12] in that year and so was readily available and anxious to please his patron. The court painter was expected to undertake a great variety of tasks ranging from the menial occupations of varnishing carriages, designing theater sets, medallions, and banners to the more important business of decorating rooms with his paintings. Alfonso certainly thought well of Dosso or he would not have included one of his paintings, a *Bacchanal of Men*, on the walls of the Camerino. Following Bellini's death, Alfonso experienced great frustrations with his plans for the Camerino. Commissions to Fra Bartolommeo and Raphael had failed to come to fruition, Titian was taking longer than promised to produce *The Worship of Venus*, and it must be assumed that Alfonso had found Bellini's concept for a Bacchanal too archaic for his taste, lacking in spirit and energy. Alfonso sought and eventually found these qualities in Titian's art.

What could have been a more simple and immediate solution to one problem facing Alfonso than to ask the court painter to enliven *The Feast of the Gods*? Dosso's intervention probably came between 1514 and 1519, the year of Titian's delivery of *The Worship of Venus*. It was in this year that Titian and Dosso made a journey together to Mantua[13] to visit Alfonso's sister, Isabella d'Este, to see her *studiolo* and works by Mantegna and Michelangelo. We presume that Titian, at an early and tender stage of his association with his new patron, Alfonso, would not wish to cause offense by criticizing Dosso's alteration of *The Feast of the Gods*. This would have to wait until later when the decoration of the room had been completed and the sheer force of the three Titians hanging together would make the Dosso alteration appear inappropriate.

Titian's repainting of the landscape in 1529 seems logical. The decoration of the Camerino was then complete and it is recorded that he stayed for eleven weeks at Ferrara, accompanied by four assistants, with no record of any painting being associated with this visit. It does not take too much imagination for us to realize how incongruous *The Feast of the Gods* looked at this moment (fig. 34). The figures and foreground by Bellini are overwhelmed by the brash, green, fantastic world of the Dosso landscape. It is only curious that Titian took so long to repaint the landscape, as he was a frequent visitor to Ferrara between 1516 and 1529.

Titian's decision to paint deliberately around the pheasant and foliage seems entirely illogical. Why would he leave two relatively small passages of Dosso's paint in his grand and justifiable attempt to integrate this painting with his own? For this, there are no answers—the two men were separated by a vast distance in reputation, talent, and creative genius.

Some or all of these questions will probably always remain unanswered, but what is more important is that we have been left with one of the most magical and fascinating paintings from the Italian Renaissance.

NOTES

1. Walker 1956.

2. Ruth Shapley, *Catalogue of the Italian Paintings, National Gallery of Art* (Washington, 1979), 1:38–47.

3. Ovid, *Fasti*, i:391–348, trans. Sir James George Frazer (London and New York, 1931).

4. Eastlake, *Materials for a History of Oil Painting* 1847; Mary P. Merrifield, *Original Treatise on the Arts of Painting* (London, 1849); Vasari, *Vasari on Technique* (1907); Laurie, *The Painter's Methods and Materials* (1849, 1960).

5. Merrifield 1849, 644.

6. Vasari 1568.

7. Venturi 1883, 113.

8. Walker 1956, 52–62.

9. Hope, 1971, 718; Fehl, "The Worship of Bacchus and Venus in Bellini's and Titian's Bacchanals for Alfonso d'Este, *Studies in the History of Art* (1974), 43–45.

10. Walker 1956, 52–62.

11. Walker 1956, 52–62.

12. Gibbons 1968, 28.

13. Gibbons 1968, 28.

APPENDIX

Photographs of *The Feast of the Gods* after removal of the discolored varnish and overpaint effectively document the paint losses, abrasions, tears, and any other damages to the painting.

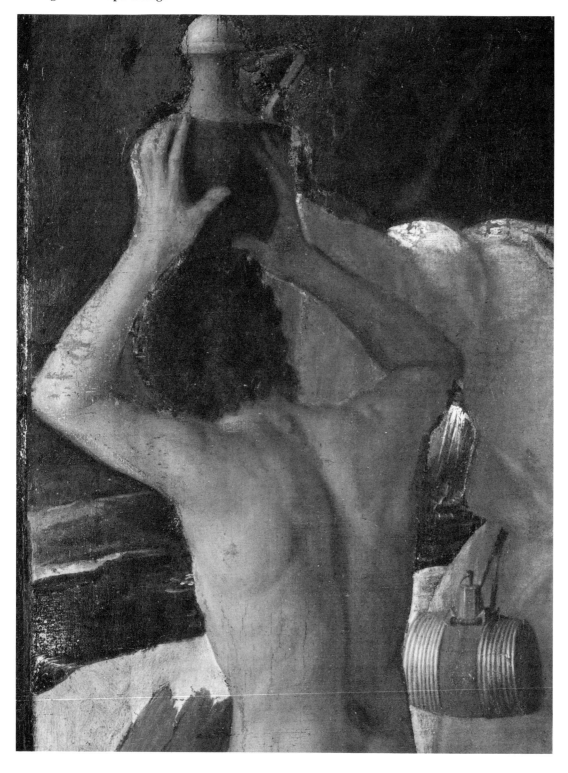

Detail, Satyr

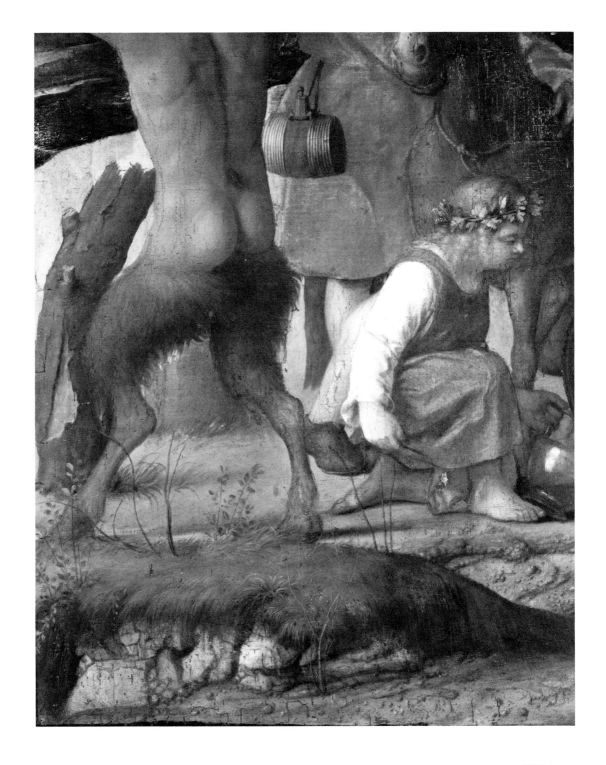

Detail, Bacchus

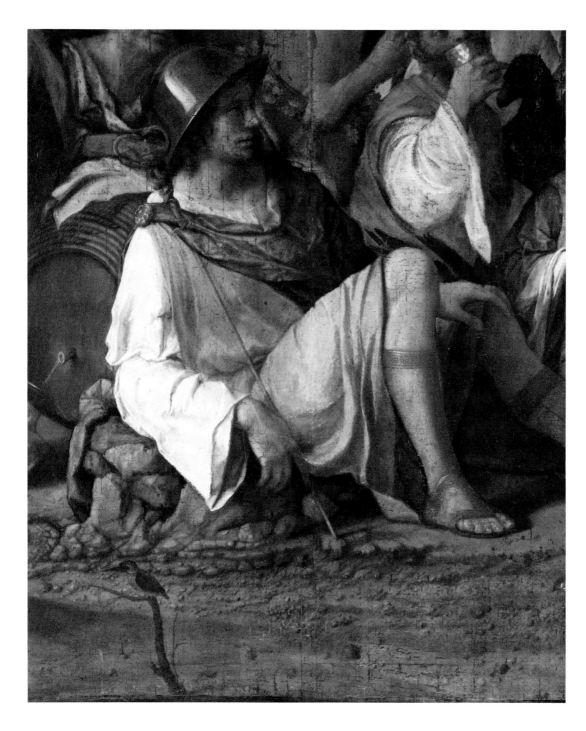

Detail, Mercury

Detail, Lotis and Priapus

Detail, Cybele and Neptune

Detail, Sky

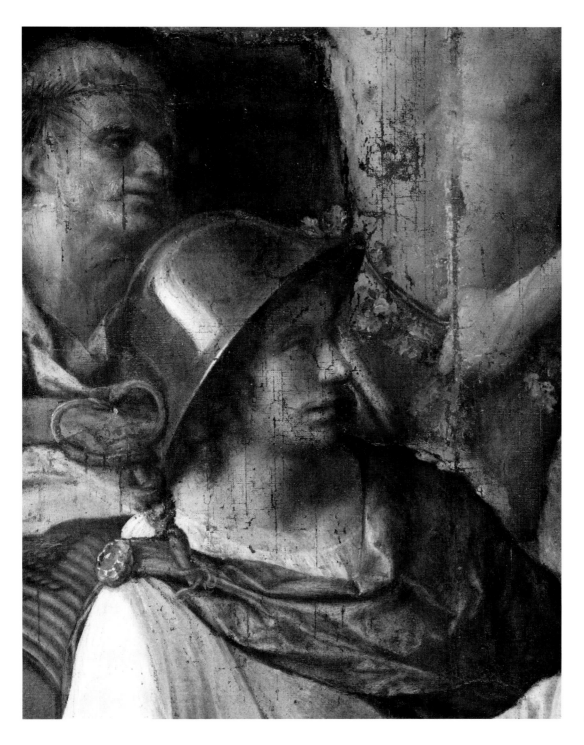

Detail, Mercury

JOYCE PLESTERS

Investigation of Materials and Techniques

The investigation began in October 1985 and was to serve a dual purpose: to obtain information about the materials and techniques used, and to discover whether technical examination could further illuminate the nature and extent of the modifications to Bellini's original composition.

Examination began by studying the surface of the picture with the stereo-binocular microscope and comparing it with the X-radiographs, infrared, ultraviolet, and raking-light photographs. A series of very small (approximately 1 cm. square) cleaning tests had been made by David Bull around the edges of the picture. From these cleaned patches, samples of the order of 0.5-1 mm. diameter of paint surface were taken for microscopical examination, chemical analysis, and preparation of paint cross-sections. Elsewhere the old varnish not only impeded visual inspection of the paint surface, but made it physically impossible to take suitably small samples. Two samples only were obtained from the main area of the picture, both from islets of paint within existing small losses. With the assistance of members of the scientific staff of the National Gallery of Art, optical and chemical microscopy, X-ray diffraction powder analysis (XRD), and energy-dispersive X-ray fluorescence analysis (EDX) were carried out on the samples. These techniques were supplemented by elemental analysis on the surface of the picture using an X-ray fluorescence analyzer.[1] A few samples were taken back by the writer to the National Gallery, London, for more detailed study and for analyses of the paint medium to be made.

The first series of samples, Series E from around the edges of the picture, gave eloquent proof of the reworking of the landscape in the upper half of the composition and a warning of the difficulties likely to be encountered in interpretation. A comparison of a pair of paint cross sections from the lower part of the picture, assumed to have been executed by Giovanni Bellini, with a pair from the upper half of the picture, judged to have been repainted by Titian, will make the point. Pl. 1 (a) shows a photomicrograph of a cross-section of Sample E5, *Blue sky between tree trunks near the right-hand edge of the picture*, just below the end of the handle of the scythe. Above the gesso ground and lead white priming are two superimposed blue paint layers, plus a trace of the old discolored varnish on the surface. Pl. 1 (b) is of Sample E1, *Blue sky, top edge, near left-hand corner.* In this section are six distinct paint layers above the white priming. Two are blue, but the lowest layer is not the blue Bellini sky, but green paint, presumably Bellini foliage. Pl. 1 (c) shows a section of Sample E7, *Yellow-green grassy foreground along the lower edge of the picture*, with only a single thin, flat layer of pale green

paint above the white priming. By contrast, Pl. 1 (d) shows Sample E2, *Green of tree near center top edge where foliage meets sky*, with six paint layers, three blue, which must represent sky, and three green, deduced to be foliage. The complexity of the layer structure in Samples E1 and E2 supports Walker's claim, based on the X-radiographs, that there is an intermediate landscape between Bellini's and Titian's.

A further discovery from Series E was the unusual composition of the paint of the Bellini tree trunks, the importance and usefulness of which was only later appreciated. Pls. 4 (c) and (d) respectively show the top surface and cross-section of Sample E3, *Brown of tree trunk, top right-hand corner*, from where the edge of the trunk just overlaps the sky. The "brown" paint of the trunk was found to be a mixture of lead white, carbon black, ochre and vermilion (red mercuric sulphide) with a final scumble of vermilion of single-particle thickness. It would seem that for painting tree trunks Bellini preferred this mixture to a simple, brown-earth pigment.

A small, roughly triangular paint loss was present in the meadow with the stag hunt in the upper left quadrant of the picture. With the stereo-binocular microscope it was possible to focus down into this tiny cavity. Projecting from under the broken edges was an intensely green glaze that was at first thought to be the Bellini landscape. Pl. 1 (e) is a photomicrograph (10x magnification) of the paint loss in the meadow and Pl. 1 (f) a photomicrograph of a cross-section of Sample E11 from an islet of paint within the same loss, with a Bellini tree trunk layer at the bottom immediately on the white priming.

A relatively short time elapsed between Bellini signing and dating his work in 1514 and Titian making his modifications to the picture. The latest date for the latter would presumably be 1529, his last visit to Ferrara to carry out work for Alfonso d'Este, giving a time difference between the completion of Bellini's work and that of Titian's alterations of a maximum of fifteen years. The first alteration in the painting would also have to be fitted into the same time span. When scientific methods are used to differentiate between original and later paint on pictures, the problem is generally that of recognizing restorers' overpaint applied half a century or even several centuries later. In the case of *The Feast of the Gods* most of the criteria for distinguishing between earlier and later paint are not applicable.[2] Often later overpaint can be identified by the presence of an anachronistic material, for example, a pigment of more modern invention than the accepted date of the original work, but, as noted earlier, within the space of time involved here, the same range of materials would have been available to all artists who worked on the painting. In fact, Bellini and Titian, both with studios in Venice, could have used materials from the same source or even the same suppliers. In such a case the most modern and sophisticated scientific methods of dating, as for example isotope analysis, or by estimation of minor and trace impurities, are unhelpful. Another useful criterion for the identification of later overpaint is to observe whether it goes over or into age cracks in the original paint beneath. Whereas oil paint becomes touch-dry in a matter of days, it is estimated to take about twenty years (depending on type of medium and pigment, and conditions of drying) for the paint film to dry completely by means of a combination of oxidation and polymerization, and it may be much longer before it is sufficiently hard and brittle to form genuine age cracks. Hence, Bellini's paint is unlikely to have formed age cracks before the first alteration to the landscape, nor would the paint of the first alteration have dried fully before Titian did his repainting. Even in the thickly painted upper half of the picture some age cracks can be seen that go right down to the canvas, suggesting that the various paint layers dried and aged almost as one.

Of prime importance is information about what lies below the surface, the layer structure of the painting. The X-radiographs give a great deal of information, and have made probably the most vital contribution to our understanding of *The Feast of the Gods*. The image on the radiographs, however, represents the sum total of the X-ray absorption of all the materials in all the layers present at each part of the picture's surface, so although a feature may

be visible in the X-radiograph but invisible at the surface to the unaided eye, the X-radiograph does not indicate at what level in a multi-layered paint structure the paint layer representing that feature may lie.[3] Nor can the X-radiograph indicate the color of the hidden paint layers, apart from the fact that such things as white clouds and white collars are likely to be painted in lead white, which, being opaque to X-rays, will appear as a white (blank) area on the X-ray film. Whereas the radiographs give general information over the whole area of the picture, minute samples of paint and their cross-sections, when studied under the microscope, give detailed information about the layer structure and composition at a particular point on the picture's surface, or, more correctly, of a very small area of about 0.5–1 mm. square. The two techniques are complementary, for the layer structure seen in the paint cross-section of a particular sample can be referred back to the X-ray image at the location of sampling.

It would obviously be more satisfactory if we could rely entirely on so-called non-destructive, that is, non-sampling, techniques of examination and analysis, but in the present state of knowledge and for this particular picture, it seemed not possible. As it was, as much information as possible was obtained by such non-sampling techniques as were available. It was mentioned above that some chemical analysis was carried out by energy dispersive X-ray fluorescence analysis (EDX), which can scan the surface of the picture principally for metallic elements. Since the majority of traditional artists' pigments are compounds of metals, the analytical results from EDX analysis may to a limited extent be interpreted in terms of pigments, and it is often helpful in confirming that a pigment identification made on a very small sample is representative of the area sampled. The technique does not serve for the identification of certain pigments, nor for paint media. A further factor that limited its usefulness in the case of *The Feast of the Gods* is that the uppermost paint layer only is analyzed. The penetration of the radiation is only approximately 10–15 microns, depending on whether the pigments present contain light or heavy elements, whereas an average paint layer has a thickness of around 30–40 microns (1 micron = 1/1000 mm.). Obviously, the method was of no use for analyzing underlayers.

The remainder of the samples were taken in April 1986, after the majority of the discolored varnish had been removed. A number of samples were intended for the dual purpose of identifying restorers' retouching and of investigating the original paint layers, from Bellini to Titian. Sampling was limited to existing small lacunae, so that some areas where the paint film was intact are not represented. Series F—the largest group, comprising twenty-eight samples—was from the figures themselves and their immediate background landscape, and taken from a horizontal band the top of which corresponds roughly with the tops of the heads of the standing figures and the bottom with the lower edge of the picture. Series B, totalling nine samples, was from the landscape background just above the heads of the figures, an area of extremely thick paint and difficult to understand from the point of view of condition, cleaning, and restoration. A Series C, of which there are only two samples from the central area of sky above Pan's head, was begun. The nomenclature was retained, but the two samples really form part of the B series. Series T, twenty-two samples in all, was from the upper part of the picture and for the most part intended to locate the presence of the Bellini tree trunks as seen in the X-radiographs and discover what layers of paint had subsequently been applied to them during the two alterations to the background landscape and in the course of previous restorations. During a third visit to Washington by the present writer in December 1988, five further samples were taken, all of green paint for comparison, including one sample from the bright green bush behind the nymph with the bowl. The location of all samples is shown in fig. 35.

It is impossible to illustrate here all the samples taken or list all the paint layers of which they are composed. A description of the various components of the painting, beginning at the lowest layer, the canvas support, is followed by descriptions of the

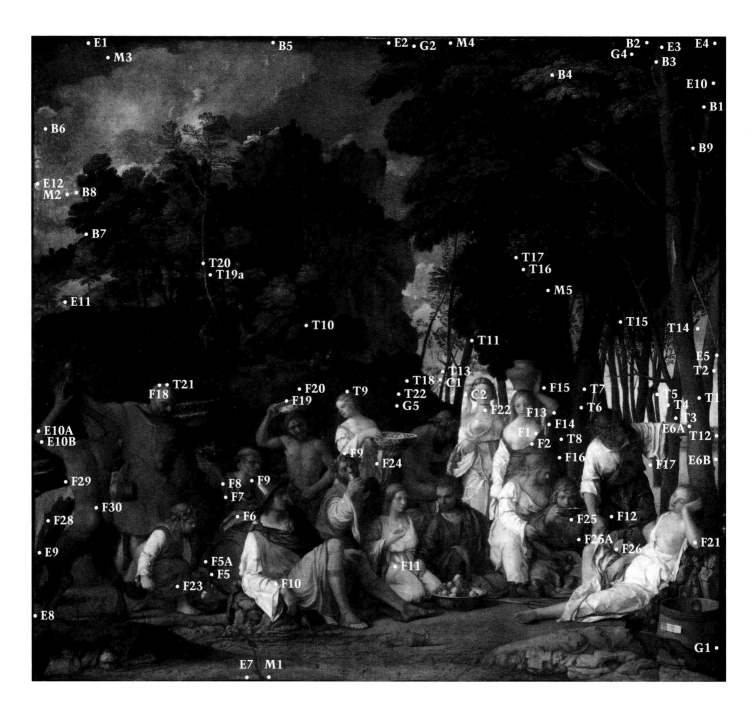

35. *The Feast of the Gods with location of samples marked*

layer structure in different areas of the picture, together with the results of chemical analysis.

The Canvas Support

The original canvas, of an unusually fine (tabby) weave, has an average thread count of warp twenty-four threads/centimeter, weft twenty-three threads/centimeter. The fiber was identified as flax and seems to be in good condition for its age, though saturated with old browned glue, most of it probably from old lining adhesive. The support is made up of three strips of canvas of unequal width (77.5, 82.6, and 33 centimeters), the two vertical seams being very unusual in that instead of having the customary overcast edges they have a line of stitches on either side of the join, visible on the surface of the picture. The original

canvas, now adhered to a lining canvas, extends almost to the edges of the stretcher.

The canvas of *The Feast of the Gods* is identical in general appearance and thread count to that of Titian's Bacchanal, *Bacchus and Ariadne* in the National Gallery, London.[4] Whereas about 95 percent of Titian's paintings are on canvas of widely varying types and weaves, about 95 percent of Giovanni Bellini's are on wood panel. The remaining five percent of Bellini's paintings on canvas are all late works. Two for which canvas data exist, the *Barbarigo Altarpiece* of 1488[5] and the *Saint Dominic* of 1515 (National Gallery, London) each have different canvas weaves from that of *The Feast of the Gods* and *Bacchus and Ariadne*. In the course of a study of the X-radiographs of the paintings by Titian in the Louvre, thread counts were made on the canvases, all of which are of different and coarser weave than that of *The Feast of the Gods* and *Bacchus and Ariadne*,[6] and so is that of the *Pesaro Altarpiece* in the church of the Frari in Venice.[7] It is known that Alfonso d'Este sent to Titian in Venice the canvas and stretcher for two of the Bacchanals, one of them being *Bacchus and Ariadne*. It seems reasonable to deduce that this rather special type of canvas is associated with Alfonso d'Este's commission for the Bacchanals. Unfortunately, at the time of this writing no data have been received for the canvases of the two Prado Bacchanals. Dosso Dossi's *Bacchanal* (National Gallery, London), smaller than the others, but possibly the first of the series, is on a coarse canvas of irregular weave.

The assymetrically-placed seams and curious mode of stitching of the canvas of *The Feast of the Gods* contrast with that of *Bacchus and Ariadne* and *The Worship of Venus*, both of which have central vertical seams, and with that of *The Andrians*, which has a horizontal seam about half way up (since the canvases of the Bacchanals are almost square, whether the central seam was vertical or horizontal when the picture was painted would not be of great significance). Again, information on the mode of seaming of the canvases of the Prado Bacchanals is lacking, but the central vertical seam of the canvas of *Bacchus and Ariadne* has the selvedges oversewn in

the usual way, and each of the two halves corresponds roughly to the commonest loom width found in sixteenth-century Venetian canvases, that is, approximately one meter.[8]

The Ground and Priming

A thin coat of gesso (calcium sulphate mixed with animal glue) was found on the canvas surface of *The Feast of the Gods*. It can be seen at the very bottom of a number of the paint cross-sections as a brownish translucent material, with on occasion a canvas fiber adhering. Originally it would have been white, but has become brown from impregnation with glue, most of which is likely to have penetrated from beneath from old lining adhesives. The gesso layer is very thin, in places barely covering the canvas grain. Above it is a second layer of ground, or rather, priming, whose purpose must have been to modify the surface of the gesso ground, probably to render it less absorbent to paint medium. The pigment is lead white and although insufficient samples were available for identification of the medium by gas chromatography, solubility tests suggest it is a drying oil. An X-ray diffraction powder pattern of the pigment showed it to have a rather unusual composition. While about 50 percent is ordinary or common lead white (that is, the basic lead carbonate, $2PbCO_3.Pb[OH]_2$), the remainder consisted of the form not often employed as an artists' pigment, the normal carbonate, $PbCO_3$, the chemical composition and crystalline form of which corresponds to the mineral cerussite.[9] The slightly lower refractive index of this form might explain the rather odd translucent, grayish appearance of the priming in some of the paint cross-sections.

A thin gesso ground is commonly found on sixteenth-century Venetian canvases and the practice of applying such a ground seems to be carried over from the preparation of wood panels. Of the canvases by Titian that have been examined so far, the majority have a simple thin gesso ground, as does *Bacchus and Ariadne*. So also does Giovanni Bellini's *Barbarigo Altarpiece*.[10] An all-over lead white priming on top of

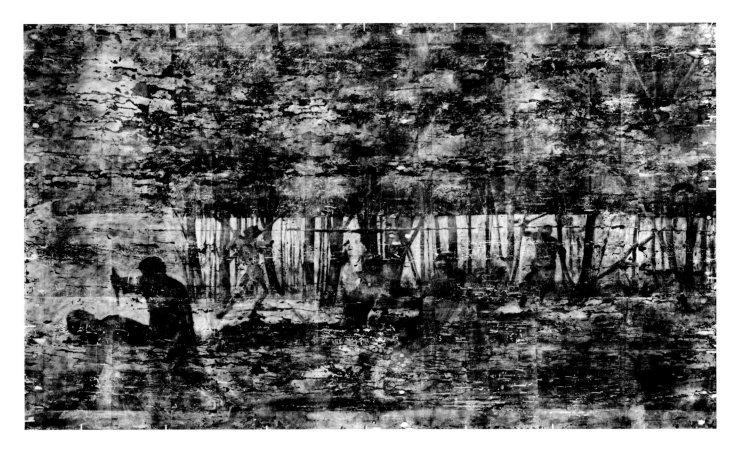

the gesso ground is rather rare in six-teenth-century Venetian painting. Lazzarini gives some examples, which include two late works by Giovanni Bellini, the *San Giobbe Altarpiece* of c. 1487 and the *San Giovanni Crisostomo Altarpiece* of 1513, though both are on wood panel.[11]

In view of the presence of a lead-based priming it is a little surprising that the X-radiographs of *The Feast of the Gods* are so clear and contrasting, and yet so detailed. No explanation can be found for the presence of the cerussite form of lead white in the priming. It is not an unknown phenomenon, but a rare one.[12]

Underdrawing

This section should perhaps be entitled "Lack of underdrawing," for up to the present no convincing evidence of underdrawing has been found in the picture, either by infrared photography or reflectography, or as a trace of pigment particles on either the surface of the gesso ground or the lead white priming.

It seems highly probable that in the upper half of the picture the thickness of the paint layers would prevent infrared radiation reaching Bellini underdrawing on the ground or priming, but the foreground, thinly painted as it is on a white ground and priming, seems to present ideal conditions for perceiving by infrared any black underdrawing that might be present. The flesh paint and the white and pink draperies would be relatively transparent to infrared and it was a surprise not to be able to discover any Bellini underdrawing even there.

Underdrawing, sometimes with hatched shadows, can often be seen in Giovanni Bellini's paintings, even with the unaided eye, and the *spolveri* of pricked cartoons have even been observed.[13] Lazzarini noted in several paint cross-sections from the *Barbarigo Altarpiece* a single line of black carbon particles on the gesso ground that must represent drawing, and drawing was evident beneath the paint of some of the figures and draperies. Reporting this, Lazzarini comments that the presence of a drawing is the norm in the paintings of Giovanni Bellini.[14] The same author re-

36. Bellini, *X-radiograph, Death of Saint Peter Martyr* National Gallery, London

ports finding traces of carbon black under-drawing in the *San Zaccaria Altarpiece* (c. 1505) and the *San Giovanni Crisostomo Altarpiece* (1513).[15] The present writer noted a thin line of carbon black particles, which seemed to represent underdrawing on the gesso ground of the Bellini *Death of Saint Peter Martyr* (National Gallery, London) (figs. 22, 36).

What then can be the explanation for one of the most puzzling results of the whole examination? Is it the underdrawing that is lacking, or our means of detection? If there was black underdrawing, even if it were iron gall ink, it should be made visible by infrared, especially in thinly painted light areas. It is, however, the writer's own experience is that infrared photography and reflectography are less successful on canvas paintings than on panel paintings, even when both have a white ground or priming. It could be that some scatter of the reflected infrared occurs on account of the canvas weave so that the reflected image is not clear. The *Saint Dominic* (National Gallery, London) shows no underdrawing on the infrared photograph, but it is, admittedly, a very dark picture. It is possible that if, in the case of *The Feast of the Gods*, an underdrawing had been done on the gesso ground, the present brownish and translucent appearance of the latter might not be sufficiently reflective in contrast with the lines of underdrawing, to give a clear image. Even in this case, one might expect to find black pigment particles on the gesso ground in at least a few of the paint cross-sections. This ought to be so even if the drawing had been done in a brown or red pigment such as sinopia or ochre, which cannot be detected by infrared. The artist could have used some organic coloring matter that is either no longer perceptible on the gesso ground or has faded.

The Feast of the Gods was one of the most complex figure compositions Bellini ever had to undertake, as well as being a new subject for the painter. It seems likely that he would have made studies on paper for single figures and separate groups. With a lifetime of experience behind him he would probably have needed only a bare outline, perhaps in charcoal, which could have

been brushed off in the course of painting, to realize the reserved shapes on the primed canvas before beginning painting.

The Pigments

The pigments identified in *The Feast of the Gods*, comprising those from all areas, samples, and layers examined, were, with the exception of two anomalous pigments found in recognizable later restorations, the same as those available in the fifteenth century. They are typical of sixteenth-century Venetian painting as has been demonstrated by Lazzarini:[16] *blue*—natural (lapis lazuli) ultramarine, azurite; *red*—vermilion (red mercuric sulphide), red lake pigments in a variety of shades; *green*—verdigris, "copper resinate" type greens, malachite (traces only); *yellow and orange*—lead-tin yellow (Type I, lead stannate, Pb_2SnO_4, identified by X-ray diffraction), orpiment and realgar (arsenic trisulphide and arsenic disulphide respectively, the former yellow, the latter orange), yellow lake (deduced to be present in one sample as a yellow glaze in which aluminum was detected, presumably in the aluminum hydroxide substrate). In addition, yellow, brown, and red shades of earth pigments were present, and lead white and carbon black (some splinterlike particles with the appearance of plant or charcoal black; others more rounded and regular, which might be bone black).

The palette is the same as that used by Titian in *Bacchus and Ariadne*, with two slight differences in emphasis. Titian used a very coarsely ground malachite for an intense bluish-green of the background foliage of *Bacchus and Ariadne*, with large pigment particles like rocky fragments (which indeed they are). In *The Feast of the Gods* this was not found: in some opaque green paint layers a few small green particles of higher refractive index than verdigris were tentatively identified as malachite. In *The Feast of the Gods* orpiment occurs mixed with realgar in Silenus' orange robe, whereas Titian in *Bacchus and Ariadne* uses orpiment for the yellow highlights and realgar for the orange shadows of the rich orange drapery of the Bacchante.

The two anomalous pigments identified

were widespread on the picture surface before the recent cleaning. The first was a pale, dull blue, with small, regular, rounded particles often clustered together in aggregates. It was noticed first on Mercury's lilac-colored tunic, where there were numerous small damages and retouchings. It was later identified as a component of a brown overpaint, in a mixture with varying proportions of earth pigments and black, and which was used liberally all over the picture to disguise damages and losses and tone down the color in some areas. The resulting brownish or brownish-green layer can be seen in the paint cross-section of Sample B3 (Pl. 4). The particle characteristics and optical characteristics of the blue pigment, combined with the presence of copper as a major constituent (identified on the layer in question by EDX analysis) suggests that it is blue verditer, the artificial form of azurite. The pigment was known and prepared certainly from the early fourteenth century onward,[17] but has not, so far as the author can ascertain, been identified in sixteenth-century Venetian paintings, the mineral form of copper carbonate, azurite, being preferred for its superior color and pigment properties. Blue verditer has been identified in various seventeenth- and eighteenth-century paintings and could well have been used by Camuccini when he restored the picture.

The second pigment was found in an upper layer of repaint on the green tree trunks to the right of the nymph with the vase on her head, in an area where much restoration had been done to cover up the excavation of Bellini sky in a previous cleaning and restoration. The pigment, hydrated chromic oxide, was invented in 1838 but not generally available as an artists' pigment until 1862. Identification from optical properties was confirmed by the presence of chromium, determined by laser microspectrography.

The Paint Medium

A few samples were taken to the Scientific Department of the National Gallery, London, to Raymond White, for analysis of the paint medium by gas chromatography and mass spectrometry. The usual form of the sample for this type of analysis is a light surface scraping of the picture surface over an area of one or two square millimeters. The first four samples, M1–M4 inclusive, were taken from the same small cleaning tests as the Series E samples and before the picture was actually cleaned. At this stage, and within such small limited areas bounded by old varnish, it was difficult to remove completely from the sample site all traces of varnish and old retouchings, either of which would be likely to interfere with analysis of the medium of the paint beneath. It was no surprise, therefore, that some of the results were not as clear as might have been hoped. They are as follows:

Sample M1 *Yellow-green foreground, lower left, presumed Bellini.*
Walnut oil, in rather low proportion to pigment.

Sample M2 *White cloud, left-hand edge, presumed Titian.*
Oil plus egg.

Sample M3 *Blue sky, top edge, left-hand corner.*
Mainly oil, some egg.

Sample M4 *Green-glazed foliage, top edge, right of center.*
Walnut oil plus aged mastic resin.

The location of the medium samples is shown in Fig. 35 and the palmitate/stearate ratios on which the identification of oil and egg is based are given in the Appendix.

Two of the results, for M1 and M4, are unequivocal. From Sample E7, *Yellow-green of foreground grassy landscape* (Pl. 1c), it can be seen that only a single green layer was present, of which walnut oil must be the medium. For M4 the presence of aged mastic resin can be explained by a trace of the old varnish on the sample site, so the medium is again walnut oil.

In samples M2 and M3 the presence of both egg and oil was puzzling. When White reported the results he had speculated as to whether the egg derived from an egg tempera underpaint that had accidentally been included in the sampling, but this seemed unlikely since the samples had both been taken from where the top layer

of assumed Titian paint is very thick. Then after the old varnish had been removed from the picture David Bull found hardened tempera retouchings covering losses and damages in the areas of the sky from which the samples had been taken, and these retouchings also spread to original paint. These had not been evident when samples M2 and M3 had been removed from the very small preliminary cleaning tests and may have contaminated the Titian paint. To test this theory a further sample, M6 again presumed Titian, was taken from a patch of blue sky near the left-hand edge of the picture, which had no old retouchings, and analyzed for medium by gas chromatography/mass spectrometry. On this occasion the presence of drying oil was established, the palmitate/stearate ratio suggesting walnut oil, and there was no evidence of either egg or resinous components.

One further sample, M5, *Glossy green paint on tree trunk near the elbow of the nymph with the vase on her head*, was analyzed for medium, again by GLC/MS. It was from a problem area. In part of the sample saved for pigment analysis some particles of viridian, a nineteenth-century pigment, were detected. White's report reads: "GC/MS examination would suggest that egg tempera is present, together with some drying oil, possibly from the lower layer. In addition there is evidence for the presence of conifer resin, probably a pine source, from the identification of methyl dehydroabietate and its oxidation product, 7-oxodehydroabietate. Specific ion scans for triterpenoid resins, such as mastic or dammar, were negative." White comments that perhaps the sample was not homogeneous and included more than one layer. This is likely to have been the case, since in cross-sections from the area superimposed thin, dark green layers could be seen covering Bellini grayish-fawn tree trunks behind and to the left of the nymph with the vase and a gap between them showing a strip of Bellini sky and landscape that was recently rediscovered in the course of David Bull's cleaning. Sample M5 was taken when there was still some later retouching on the glossy green. The pine resin that was identified in the sample is most likely to derive not from the later retouching but from the green copper resinate of the glossy green layer.[20] The presence of egg is puzzling, for the sample comprised only green paint, so whether it is associated with the work of one of our sixteenth-century masters or a restorer of a later date is not known.

As mentioned above, samples for medium analysis are normally taken from the surface of the painting, that is, the uppermost paint layer. At present there is no practicable method for analyzing the media of the separate layers of a multi-layered sample by the most reliable methods of GLC/MS. Systems of staining with biological stains have been worked out for the identification of media in paint cross-sections,[21] but serve only to distinguish between egg and oil, without differentiating between different types of oil.

No attempt has been made so far to identify the medium of the first alteration to the landscape. From the results above it is seen that both Bellini and Titian used walnut oil, and there seems a good chance that the painter of the first alteration may also have used it.[22]

A Note on The Interpretation of the Layer Structure of the Picture and Its Relation to the Order of Painting

Provided that each artist painted in a single layer within well-defined contours of the forms, the interpretation of paint cross-sections in terms of order of painting and even authorship would be a comparatively simple process, even if a work involved more than one painter. This situation is almost never encountered. *The Feast of the Gods* is a picture in which, for one reason or other, layers proliferate. With our knowledge of the techniques of fifteenth- and sixteenth-century Venetian paintings it is obvious that each artist involved would often have employed superimposed layers—underpaint, glazes, scumbles—in the modeling of forms and to achieve particular nuances of color. While it may be stated that on the whole Bellini painted in thin, flat layers, few in number and generally in a logical sequence (unlike Titian),

his method of painting the background first, leaving the figures (and in *The Feast of the Gods*, the tree trunks also) in reserve and returning to paint them afterward, of itself generates multiple layers. This happens when the paint of the figures, or tree trunks, goes slightly over the edge of the already-painted background. Bellini also added small details such as the shaggy hair of the satyrs, Pan's pipes and horns, the hanging drapery of a sleeve, or a crossing branch of a tree on top of the completed landscape, because it would have been tedious and fiddling to leave such small areas in reserve. Like most painters, of course, he added final touches such as features of faces and hair and details of costume and accessories, on already-painted areas.

It is clear from the X-radiographs that the majority of Bellini's tree trunks were painted out. It is not so evident to what extent the Bellini foliage of the trees was covered in either the first alteration or in Titian's repainting. The same may be said to be true of Titian covering the first alteration; he may simply have added some foliage on top of and among that existing already.

At both stages of the repainting of the landscape there would be the question of effectively obliterating unwanted features. The Bellini tree trunks set against the bright sky are such a powerful feature of the original design that they would require a very opaque paint (of high hiding power) to block them out. A green glaze would not have sufficed; a coating with a high content of lead-tin yellow or lead white would have suited admirably, and that this was what was employed is suggested by the dense white patches in the X-radiograph above the heads of the figures on the left and among some of the branches higher up. Titian would have had the same problem when he came to paint out the first alteration. Hence the paint cross-sections should be scrutinized for any intermediate obliterating or isolating layers between the original Bellini and the first alteration, and the first alteration and Titian's repainting.

In the interpretation of paint sections in general it must not be forgotten that each comprises only 0.5–1 square millimeter of paint surface, so may not always be typical of the area as a whole, which is the subject of investigation. Lazzarini uses the term *pennellata* (a stroke or touch of the brush) for thin paint layers, which may merely indicate a very short brushstroke, or the artist flicking his brush a second time over the same spot, rather than a continuous paint layer across the area of interest. By the sixteenth century we can no longer presume that painters will apply their paint in the ordered and logical manner of the early fifteenth century. Attempts to arrange the photomicrographs of paint sections from different parts of *The Feast of the Gods* so as to line up the layers at various levels were not always successful, nor was the matter helped by the fact that the lead white priming and gesso ground were sometimes left behind in the difficult task of excavating the total thickness of all the strata. When that was the case it was often not possible to say whether or not the lowest paint layer in the cross-section was the first coat applied to the priming.

The Bellini Figures and Foreground

The investigation of the figures and foreground was rather more straightforward than had been envisioned. For this reason, and because Bellini comes first in the chronology of the picture, an account of the examination of this part of the picture will be given first.

Blue Draperies

Ultramarine (the natural, lapis lazuli variety) is used throughout the blue draperies, except for a trace of azurite in the underpaint of two samples. For the principal paint layers it is always used mixed with a proportion of lead white, which serves to give a compromise between brightness and saturation, that is, a blue color that is at once intensely blue but not dark. Ultramarine unmixed with white and in an oil medium tends, because of its low refractive index, to produce a dark translucent blue that becomes even darker with age and also dries slowly. Paint cross sections of samples from the blue draperies revealed

that the subtle nuances in color were all produced by the use of slightly different underpaint. Pl. 2a shows a cross section of Sample F23, *Blue of Bacchus' dress after cleaning; from small loss in the skirt.* On the white priming there is first a very pale blue layer of lead white mixed with fine particles of ultramarine. This is followed by a thick, brilliant blue layer of packed ultramarine particles, some very large and intensely blue, in a matrix of lead white, with finally a glaze of coarsely ground ultramarine, spread in almost single-particle thickness in a translucent medium. This sequence represents the most efficient system for obtaining what might be described as the bluest of blue. The shadows, where the blue glaze is thicker, are a deeper blue. In Pl. 2b, Sample F24, *Blue dress of the nymph with the bowl*, it can be seen that the first paint layer in the cross-section is pink, lead white suffused with a pink color and with a few undispersed flakes of crimson-colored lake pigment, including a large purple-red globule in the center, and one or two ultramarine particles to add a mauve tint. The second paint layer is very like the second blue layer of Bacchus' dress, very thick with packed large ultramarine particles, with the difference that the pink color from the layer below seems to seep upward into it, as if a pink glaze or wash had been taken up into the top layer by painting wet-in-wet. Finally there is a glaze of single particles of ultramarine, as on Bacchus' dress. Knowing the paint layer structure, one can appreciate better on the picture itself a faint hint of mauve in the nymph's dress. Pl. 2c is of Sample F2, *Blue dress of nymph with the jar on her head; from proper left breast* (Samples F1 and F2 were taken to investigate the *pentimento* of the blue drapery beneath the flesh paint of the breast of the nymph with the jar, a matter that will be dealt with below when the various alterations to the figures are discussed). Immediately on the white priming is a thin gray layer, iii, containing a few small vermilion particles. It has nothing to do with the underpaint of the nymph's blue drapery, but is the paint of a Bellini tree trunk just behind her, the large tree trunk that in the X-radiograph seems to be growing out of her pot. The paint of

her blue drapery must just have overlapped the edge of the tree trunk when the artist was filling in the space reserved for her figure. The next layer up, iv, is grayish-blue, opaque, and moderately thick, and the blue pigment is dispersed as very small particles, with only a very few larger particles recognizable as ultramarine. Layer v is a darker grayish blue, but similar to iv, while vi is lighter and bluer, the blue particles including a few of azurite as well as ultramarine. The final layer, vi, is of ultramarine and lead white, of a deep blue color and quite thick. The lack of a final glaze is explained by the sample having been taken from a highlight. The underpaint probably imparts to this nymph's dress a very slightly darker and greener shade of blue than that of her companion. Pl. 2d shows a section of Sample F25, *Blue of Apollo's tunic, left side of chest.* It has on top of the priming what seems to be a single, blue layer, extremely thick, of ultramarine, with only a little lead white. It was noted that the layer did seem darker and of a more purple tone near the bottom, where in fact there is a large globule of purple-red lake. Under ultraviolet light it was apparent that the single, thick, blue layer was really two, the lower third fluorescing a dull purplish-red indicating the presence of a red lake pigment. These two layers produce yet another slight variation on the ultramarine theme.

Bellini has obviously taken trouble with the painting of the blue draperies, but it need not surprise us that the blues are thick and multi-layered. As early as in the 1840s both Charles L. Eastlake and Mary P. Merrifield noted that in Italian pictures the blues were often raised above the surface of the other colors. Merrifield reports that a Milanese artist of her acquaintance attributes this to the necessity of repeating the color several times.

Red and Pink Draperies

Vermilion occurs only in the scarlet of Jupiter's cloak, practically in the center of the figure group. No sample was taken from Jupiter's cloak or sleeve because the paint surface is intact and very hard, although

David Bull, in examining it carefully under magnification, detected signs of some old repaint that would be very difficult to remove. Vermilion was confirmed by the detection of mercury at the paint surface by means of X-ray fluorescence analysis. Vermilion is also used sparingly in Priapus' green- and red-shot *cangiante* tunic, for which see under *Green draperies*, below.

Red lake pigments play an important part in the draperies, and are of varying shades, but mostly used to give pale to rose pink tones as in Silvanus' robe, the drapery over the barrel, and the dresses of Cybele and Ceres. Only in Neptune's crimson cloak and the purple of Mercury's tunic is a red lake pigment used thickly and at full strength as a glaze on the pink and blue underpaints respectively. Fortunately, from the point of view of conservation, the parts of the drapery with red lake pigments were in good condition, but, unfortunately from the point of view of identifying the pigments, it was not possible to obtain a suitable or sufficient sample for analysis of the lake dyestuff by thin-layer chromatography or liquid chromatography, the most reliable methods of identification.[23]

The pink of Cybele's dress is very subtly contrived to give a slightly *cangiante* effect of an apricot color shadowed with deeper pink. Pl. 2f shows a cross section of Sample F11, *Pink of Cybele's dress, just below her waist*. There are three paint layers above the priming, but these must not be interpreted as evidence of the dress having been repainted. The sample comes from a highlight applied on top of the shadow of a fold. The lowest pink layer, a mixture of red lake pigment and lead white, is the general all-over color of the garment; the middle, a glaze of purple-crimson lake, the shadow of the fold, and the top layer the highlight on the fold. The top layer incorporates one or two granules of lead-tin yellow. A stronger yellow highlight can be seen on the bodice of the dress itself.

For other incidences of lake pigments see above under *Blue draperies* and below under *Yellow and orange draperies*.

Green Draperies

No samples were taken from Mercury's cloak or Neptune's robe since these are both in good condition. XRF analysis on the picture surface indicated copper, lead, and tin as the principal elements present. From observation with the stereo-binocular microscope it looks as if both garments are painted in the usual mixture of lead-tin yellow with verdigris and/or malachite, with a glaze of "copper resinate" green that may have become a little warmer and more golden in tone with age and exposure. A sample was taken from Priapus' red- and green-shot *cangiante* tunic. The drapery is first painted in much the same way as Mercury and Neptune's green cloaks, with a deep green glaze over a yellow-green underlayer. The highlights were then applied with an extremely thin scumble of vermilion. In the sample taken, F12, *Red highlight on Priapus' green- and red-shot skirt* (Pl. 2g), the scumble of vermilion is made a little lighter and more opaque by the addition of a small amount of lead white. Mixture with a white pigment also slightly changes the hue of vermilion from a scarlet to a more pinkish red. Vermilion is, of itself, one of the most opaque of all pigments, so light is not reflected back through it from the green layer beneath; if instead of vermilion a red lake glaze had been used, the resulting color of the highlights would probably have been brownish.

Yellow and Orange Draperies

Lead-tin yellow was identified by X-ray fluorescence analysis on the surface of the painting in the yellow highlights of Cybele's dress, and the yellow of the blue and yellow *cangiante* drapery of Jupiter's sleeve.

The orange color of Silenus' cloak and that of Apollo both have as principal pigment the orange arsenic disulphide, realgar, but, as in the blue draperies, there is a very slight difference in color. Silenus' robe was guessed from examination under the stereo-binocular to be a mixture of realgar and orpiment when the glistening fiber-like crystalline particles of orpiment, the

trisulphide of arsenic, scattered among the more granular orange-red realgar, were seen. The presence of arsenic was confirmed by X-ray fluorescence analysis carried out on the relevant areas of the picture. Pl. 2h shows a cross-section of Sample F8, *Orange drapery hanging from Silenus' left hand over the ass' flank*, taken before removal of some reddish repaint, which covered losses in that area. The layer immediately on the white priming is (as in Sample F2 from the blue of the dress of the nymph with the jar) a Bellini tree trunk that the edge of Silenus' drapery must just overlap (a whole cluster of tree trunks can be seen in the X-radiograph just behind Silenus and his ass). The first orange layer above this contains a lot of flakelike yellow particles of orpiment, while that above it contains almost none. The very thin top layer is red ochre repaint from past restoration. Apollo's orange cloak is essentially realgar with almost no orpiment, but in a sample, too small for a section, it could be seen that a pinkish lake pigment was mixed with the realgar in the upper part of the layer. Under ultraviolet light the sample was seen to fluoresce a purplish pink, and specks of the lake pigment could be discerned. Hence the slight differentiation between the orange of Silenus' robe and Apollo's cloak. The orange of the nymph's dress is of a more complex character. Although a little realgar was found in a sample from a deep shadow near the waist, the remainder of the drapery seems to be based on lead-tin yellow and lead white with the addition of a little vermilion in the shadows. In the writer's experience orpiment and realgar seem to have been rather rarely used in European easel painting except in sixteenth-century Venice. Before 1500, if an orange color was required it was usually made from a mixture, such as vermilion with lead-tin yellow. The rather granular-looking orange and yellow paint typical of orpiment and realgar does not seem to occur in Bellini's pictures before that time, nor is the color orange as such much seen in his earlier works. (Documentary sources would suggest a more widespread use, but examination and analysis of paintings does not bear out this suggestion.)[24]

White Draperies

The white draperies are in good condition and the only sample it was possible to take was F4, *White of proper right sleeve of nymph holding a bowl*, from a small damage between the leaves of Jupiter's laurel wreath, and too small for a cross section. It consisted of a single layer of lead white directly on the white priming. It was interesting to note how much whiter and more opaque the white paint of the sleeve looked than the white priming beneath, the white priming now known to contain about fifty percent common lead white, that is, the basic lead carbonate, and about fifty percent of the less frequently encountered normal carbonate, the composition and crystalline form of which corresponds to the mineral cerussite and is a little less opaque. There were a couple of red lake particles in the sample of white from the nymph's sleeve, but their presence may have been fortuitous. Parts of the hanging white sleeves of the nymphs and of Priapus are painted on top of the green background, though Cybele's white sleeve was left in reserve in the first lay-out of the composition.

The Flesh Paint

Bellini painted the flesh of the gods and the nymphs in a lighter tone than that of the satyrs, and the flesh of the female figures lighter than that of the males. A preliminary scan of the flesh paint of the various figures was carried out by X-ray fluorescence on the surface of the picture before cleaning.[25] The lead identified in the areas of flesh of the satyrs and Pan comes for the most part from white priming beneath the flesh paint. The flesh paint itself is very thin and in the darker parts can be seen to be just a scumble of carbon black containing occasional vermilion particles, so it is not surprising that the figures of the satyrs and Pan are comparatively transparent on the X-radiograph. Their flesh paint is in fact not very different from the Bellini tree paint. Pan's chest showed a rather higher concentration of mercury than in the flesh of the satyrs, and it does

appear a little ruddier from the slightly higher concentration of vermilion. Pl. 3a shows a cross section from Sample F30, *Flesh of satyr, extreme left of picture*, taken from his back, middle tone, where there is a little more modeling. There is a thin light orange-brown opaque layer of ochre and lead white under an exceedingly thin scumble of vermilion and black of single-particle thickness.

X-ray fluorescence analysis detected lead white and mercury as the principal elements (iron and copper being trace elements) also in the flesh of the gods and nymphs. Little difference was found between results from the various figures. The god Mercury's face gave a slightly higher reading for mercury (the chemical element!), and is indeed of a deeper pink than the nymphs' faces. The breasts and cheeks of the nymphs with the braided hair and those of Lotos gave such similar results that the X-ray fluorescence scans could be superimposed.

The above readings were made partly to gain some idea of the composition of the flesh paint and its likely appearance after cleaning, and partly to gather evidence for or against the claim that has often been made that Titian repainted some of the flesh of the female figures.

Sample F21, *Lotis' flesh, forearm near elbow*, of which a cross section is shown in Pl. 3c, was from a patch of checkered small losses that followed the canvas weave. A single, moderately thick pink layer has many scattered tiny vermilion particles, and no evidence of lake pigment. The flesh of the nymph with the braided hair also consisted of a single layer, quite similar but with fewer and slightly larger vermilion particles. Apart from where there are *pentimenti* of the necklines there seems no possibility for the flesh of these two figures to have been repainted, since only a single paint layer is found on the priming of the canvas. It must be remembered that even Bellini would have been obliged to use a fair amount of lead white in the painting of nude female flesh in order to achieve a sufficiently luminous effect.[26]

Alterations to the Figures and the Foreground Landscape with Relation to Bellini's Order of Painting

Bellini generally proceeded by leaving his figures in reserve, painting the background around them and then returning to fill in the figures in the reserved spaces on the ground or priming. In the case of *The Feast of the Gods*, he used this method for tree trunks as well as figures. The figures, the dark flesh of the satyrs in particular, are thinly painted, as is also the foreground landscape beneath the figures' feet. When light was directed through the back of the canvas, the Bellini figures, the lower foreground, and the visible tree trunks, including the tall ones on the right, were seen as bright silhouettes against a black background of the upper landscape, the latter so thickly painted as to be impenetrable to light. The exception was the figure of Silvanus, which appeared moderately opaque by transmitted light. In the X-radiograph he is a grayish blur. It became clear on examining the picture under the stereobinocular that the figure of Silvanus had been painted on top of the yellow-green foreground landscape. His flesh is very thinly painted and dots of yellow-green can be glimpsed where the flesh paint has worn on the tops of the canvas threads. The one sample that it was possible to take, from a damage on the neck, shows not the Bellini green landscape, but a layer of typical Bellini tree trunk paint, and referring back to the X-radiograph, there are the images of enormous tree trunks behind Silvanus' head. On the X-radiograph a dense band of repaint, which must belong to the first alteration to the landscape, all but obliterates these tree trunks, so the figure of Silvanus must have been painted before the first alteration to the landscape had been made, but after Bellini had painted his grassy foreground landscape. A sample was also taken from Silvanus' pink drapery in the course of trying to disentangle the rather confusing, and at the time much overpainted, area where Silenus' orange sleeve meets Silvanus' pink drapery and the pink drapery over the barrel. Pl. 3e, Sample F27, *Highlight on Silvanus' robe*, shows the paint cross-section, and it can

be seen that Silenus' orange robe, which itself extends slightly onto the green landscape, is under Silvanus' pink drapery, which in turn overlaps its edge. Silvanus' flesh and drapery are painted in thin flat layers, with no anachronistic pigments, and consistent with Bellini's painting of the other figures.

The *pentimenti* that represent the lowering of the necklines of the nymphs' dresses are described on page 66. It was possible to take samples only from the nymph with the jar on her head. A small paint loss had occurred just above her left breast from the edge of which it was possible to take one sample, F1, from the blue drapery over her shoulder and another, F2, from the *pentimento* of the neckline where blue paint can be seen beneath the flesh paint. Pl. 4e shows a cross section from Sample F1, *Proper left breast of nymph with jar with* pentimento *of blue drapery beneath* and Pl. 2c the cross section of Sample F2, *Blue of dress of nymph with jar; from just below F1.* In both samples the layer immediately above the white priming is Bellini tree trunk paint, with scattered tiny vermilion particles in a gray matrix, and, as might be anticipated, the X-radiograph shows an enormous tree trunk over the edge of which the painting of the nymph must have spread slightly. Above the Bellini tree trunk paint in both samples is a grayish-blue layer, moderately thick, with very finely ground pigment particles, only the largest recognizable as ultramarine. In Sample F1 this blue-gray layer is of variable thickness, a peak at the center almost penetrating the flesh layer above. The flesh paint is of a pale peachy color consisting of lead white with a few vermilion and one or two lake particles. In the section of Sample F2 are a further three blue paint layers, the top one deep blue and consisting of ultramarine with little lead white. The *pentimento* has become more visible partly on account of slight wearing and partly because of the tendency of oil paint to become more translucent with age.

Pl. 3f, Sample F26, *Blue of Apollo's sleeve of arm holding the* lira da braccio, shows a cross-section of a sample of paint taken from the edge of the vertical crack in the angle made by Lotos' drapery and the edge of the *lira da braccio.* No fewer than four separate green layers (iii–vi inclusive) are found above the white priming and under the blue paint of the sleeve. This number would not be unreasonable if the sleeve had been painted over the detailed green foliage to the right of the *lira da braccio* in the pentagon of paint surface in question. The blue of the sleeve in the same section comprises three layers. Layer viii is a pale blue in which both ultramarine and a few azurite particles are seen, and peters out on either side of a vertical crack (ix), a blue layer of packed coarsely ground ultramarine particles with very little lead white, and (x), a glaze of large ultramarine particles in a translucent medium. These layers do not tally with the blue layers in Sample 25 (see Pl. 2e) of Apollo's blue robe, taken from his chest, where there was what appeared to be a single deep blue paint layer (but discovered to be really two, the lower part containing a purplish lake pigment). In the section of Sample 26, *Blue of Apollo's sleeve of arm holding the* lira da braccio, it may be noted that there is, between the green of the landscape and the blue of Apollo's sleeve, a very thin orange-brown line. It was at first thought that this might be the equivalent of the thin orange-brown line in Sample E1, *Blue sky, top edge, near left-hand corner* (see Pl. 1b, page 78), which seems to be a sort of isolating layer between the paint of Titian's sky, which we now see, and the paint layers beneath. What is more, the orange-brown line in Sample 2b was seen to fluoresce slightly when examined under illumination of 400nm wavelength. The orange-brown line in Sample E1 was recognized as merely an extension of Apollo's cloak, the lake pigment of which fluoresced.

The Foreground Landscape

The terrain in front of the figures is very thinly painted, much of it in a single layer of paint. Under the stereo-binocular microscope there can be seen in thin, worn areas the white priming and even the canvas

threads. A paint cross section from sample E7, *Bellini yellow-green grassy foreground from bottom edge of picture*, has been illustrated in Pl. 1c and showed a single yellowish-green paint layer with the discolored varnish still in situ. X-ray fluorescence on the picture surface and X-ray diffraction powder analysis of a sample showed that this yellow-green Bellini foreground consisted of lead-tin yellow type I (the more usual of the two forms), with a little of a green copper pigment, which judging from the appearance of the particles under the microscope (of comparatively low refractive index) and the absence of the characteristic X-ray diffraction pattern of malachite was likely to be verdigris. Some lead white was also present. The medium, ascertained by gas chromatography, of a sample from close by, was walnut oil, with a rather low ratio of oil to pigment, which seems to be confirmed by the rather dry, "lean" appearance of the paint.

Having painted the foreground landscape with the shapes for the figures (and tree trunks) left in reserve as the white priming, Bellini, in returning to fill in the figures, seems often to have extended the paint over the edges of the surrounding landscape. The fur of the satyrs, the contours of the ass' legs, the lower edge of Lotos' left foot, and a bit of Priapus' tunic, go over the edge of the yellow-green Bellini foreground. He has also painted some larger features on top of it, notably Priapus' dangling white sleeve. The same system was used for the tree trunks as for the figures.

In several places, though, there is between and around the figures a second, thicker layer of yellow green, just slightly yellower than that beneath. It is most evident around the body of the satyr farthest to the left, where it is thick and dense also on the X-radiograph, and can be seen in swirling brushstrokes quite different from the thin, flat paint of the Bellini grassy foreground. It goes over some of the edges of many of the forms of the figures and tree trunks, sometimes overlapping the edges of forms that themselves overlap the edges of the Bellini yellow-green foreground. The chemical composition of the two yellow-green layers is virtually the same, except for a higher proportion of lead-tin yellow in the top layer. In other places the upper layer of yellow-green stops just short of the contours of figures and trees, as if applied rather hastily. The same layer also seems to cover part of the bases of two of Bellini's tree trunks, one just beside Silenus' right leg, the other just under Priapus' left sleeve.

One puzzling feature of the foreground landscape, the nature of which was explained by the paint layer structure, is the broken tree stump between the left edge of the picture and the left leg of the adjacent satyr. Where there are tiny losses in the paint, the yellow-green of the Bellini foreground can be seen. A cross-section of Sample F28, *Stump of tree, lower left*, Pl. 4f, shows the tree trunk painted on top of a single layer of yellow-green Bellini foreground. The tree trunk paint is characteristic of Bellini: a grayish matrix with tiny scattered vermilion particles, and in this case a couple of azurite, perhaps to counteract the yellow of the paint beneath.

The dark blue-green stream that flows just below the arm of the satyr at the far left, and above the tree stump just discussed, is painted in a thin glaze of azurite on the single yellow-green paint layer of the foreground. The azurite glaze has probably become more translucent with time so that the stream now looks dark green instead of blue.

The Background Landscape behind and above the Figures

The first series of samples, Series E, as already mentioned, served to show a multiple layer structure in the upper landscape.

Series E was confined to the edges of the picture. The second stage of sampling was carried out after removal of the varnish and a considerable amount of obvious restorers' retouching and repaint, and of the fillings in the cleavages around the contours of the upper halves of the figures. After removal of these fillings there could be seen, in the resultant gap between the thin paint of the Bellini figures and the thick

dark paint of the background foliage, various underlayers protruding from beneath the latter, including a bright green glaze and a yellow-green layer not unlike the Bellini foreground grassy landscape. As anticipated, the central band of landscape background was multi-layered. The pigments used in Venetian pictures of the early 1500s would likely be ultramarine and/or azurite, together with lead white for sky and clouds, and combinations of verdigris and/or malachite, copper resinate greens, lead-tin yellow, and lead white for foliage. For architectural features the artist would have been unlikely to stray far from a palette of lead white, carbon blacks, and earth pigments. Hence pigment identification as such, even carried to the extent of analyzing individual layers of the paint cross sections by means of the scanning electron microscope combined with X-ray fluorescence analysis, or by laser microprobe analysis, would not take us very far.

The "Bellini Tree Trunk Paint"

It was more luck than judgment that gave the first important clue to the identification of the artist of the landscape in the background. As mentioned earlier, this was the recognition of the rather unusual composition and build-up of the paint of the Bellini tree trunks. The gigantic ones on the right extending to the top of the picture, and some nearby associated subsidiary ones and branches, were left untouched in both stages of alterations to the picture, appearing on the X-radiograph as they do on the picture surface. The paint of the brown trunks, instead of consisting of brown earth pigments, was found to have a grayish, or sometimes fawn-colored, matrix of a mixture of lead white, carbon black (some recognizable splinter-like fragments of charcoal black), sometimes a little brown ochrelike pigment, through which were sparsely scattered minute, glistening bright red crystalline particles of vermilion (red mercuric sulphide). This unlikely mixture of pigments produces a subtle mauve-gray to pinkish-fawn, depending on the proportions of the ingredients. The writer had encountered similar

mixtures in some early works of Giovanni Bellini, but not in tree trunks. The first example was in the purple brown rocky landscape in what may be the artist's earliest-known work, *Saint Jerome Preaching to the Lion* (Barber Institute, Birmingham), next in the rocky landscape of *The Agony in the Garden* (National Gallery, London), than as the purplish-brown of a "porphyry" relief depicted in *The Blood of the Redeemer* (National Gallery, London).[27] It is interesting to note that Lazzarini found that although vermilion was not used as a red color *per se* in the *Barbarigo Altarpiece*, it appeared as a component mixed with carbon black, lead white, and ochres in all the brown colors in the altarpiece. Last, during a recent examination by the author of *Death of Saint Peter Martyr* (National Gallery, London), the trunks and branches of the trees were found to be painted in a similar mixture. It would be satisfying to be able to say that this pigment mixture, characteristically containing vermilion, and substituting in the palette for brown, was specific to Giovanni Bellini, but such a mixture was also encountered in some brown colors, for example of hair, in the Cima altarpiece, *The Incredulity of Saint Thomas* (National Gallery, London).[28] Cima was, of course, a pupil and imitator of Giovanni Bellini. However, within *The Feast of the Gods*, what will henceforth be termed "Bellini tree trunk paint" had a distinctive appearance such that it was possible from the glinting of the tiny scarlet vermilion particles to recognize it in paint cross sections several layers beneath the surface. No fewer than twenty-five paint cross sections of samples featured a Bellini tree trunk layer, in ten of which it was the top layer. In the remaining sixteen (for the most part taken for purposes other than locating the tree trunks) it was an underlayer, and in every case the location of the sample corresponded to a Bellini tree trunk as seen on the X-radiograph. Fig. 37 shows the location of the twenty-six samples marked on a black and white photograph, fig. 38 opposite, the same samples marked on the X-radiograph. This at any rate is proof that Bellini did actually paint the hidden tree trunks and not just leave them in reserve

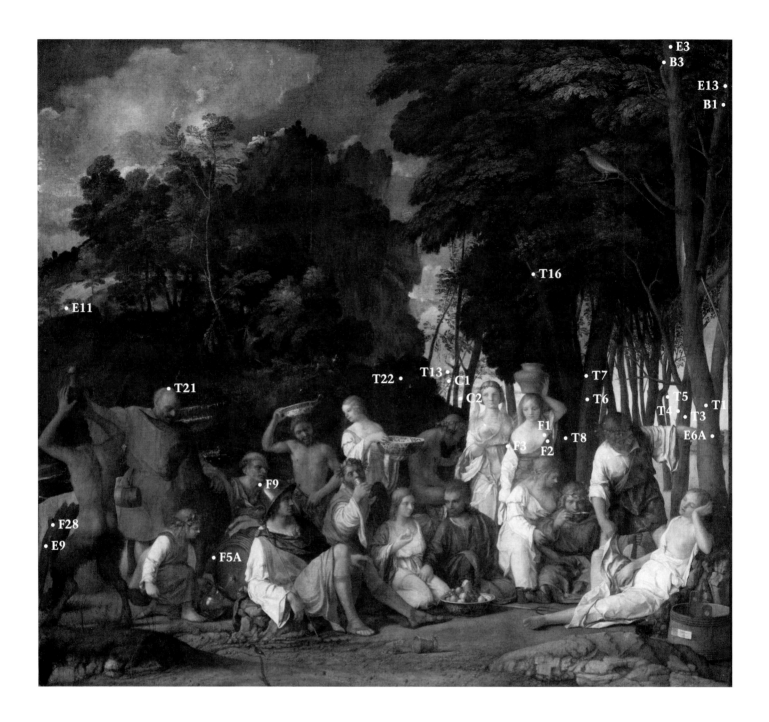

37. *The Feast of the Gods, with location of Bellini tree samples marked*

as unpainted forms. Pl. 4a–h, page 81 illustrates a selection of the cross sections with the Bellini tree trunk layer. Pl. 4a, Sample T3, *Center of second tree trunk from right, just above Priapus' arm*, shows the tree trunk paint of the visible Bellini tree trunk directly on the white priming. There are actually three very thin layers superimposed, probably representing modeling. Sample T4 (Pl. 4b) is from the same tree trunk but from where the edge of the tree trunk just overlaps the edge of the already-painted Bellini cream-colored sky, in this case with two layers of tree trunk mixture. Sample E3, *Brown of tree trunk, top right-hand corner*, PL. 4d, is taken from where the tallest visible tree trunk meets the top edge of the picture, and has pinkish-brown bark. Pl. 4c shows a photomicrograph of the top surface of the sample before mounting and sectioning, with clustered small vermilion particles on the surface;

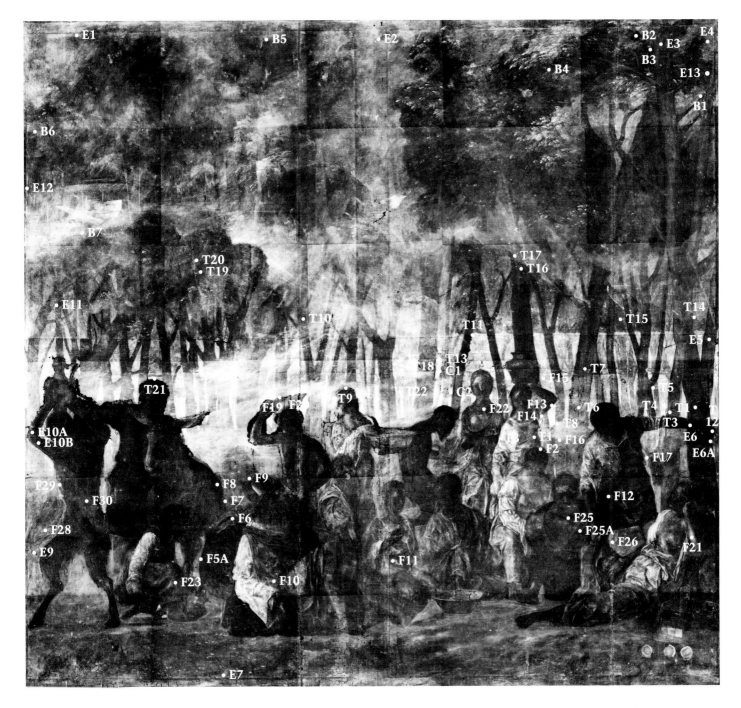

38. *X-radiograph, The Feast of the Gods, with Bellini tree samples*

Pl. 4d the cross section of the same sample, the edge of the tree trunk extending over what must be a patch of Bellini azurite sky, since it is directly on the lead white priming. Sample FI (Pl. 4e), *Proper left breast of nymph with jar, with* pentimento *of blue drapery beneath*, already discussed, shows the paint of the Bellini tree trunk that is just behind and to the right of the nymph, directly on the priming. Sample F28 (Pl. 4f) *Stump of tree, lower left*, is the

tree stump added by Bellini himself on top of his yellow-green foreground landscape. Sample B3 (Pl. 4g), *Patch of ultramarine sky, close to tree trunk top right corner*, has a thin layer of Bellini tree trunk sandwiched between what must be Bellini azurite sky and the ultramarine sky now visible which may be Titian's (at any rate, only one painter apart from Bellini can have been at work here). Finally, in Sample T22 (Pl. 4h), *Dark background foliage to*

left of and above Pan's head, the Bellini tree trunk paint, applied directly on the white priming, is beneath five layers of sky and foliage.

Another recurring feature, in samples from the middle and upper landscape, but not the foreground containing the figures, was a bright line of fluorescence seen between certain pairs of paint layers when some paint cross sections were examined under the microscope illuminated by ultraviolet or by visible blue monochromatic light. Two other paint layers seemed to be present only in certain samples from the central band of landscape background just behind and above the figures. The first was designated the "purple layer," since it contained both blue and red particles; the other, more extraordinary, and unique in the author's experience, consisted of azurite and red lake pigment in a matrix of green glaze. It might be termed the "green-blue-and-red" layer.

The Fluorescence Between Paint Layers Under Blue or Ultraviolet Light

This was probably the most significant discovery apart from the Bellini tree trunks, but much more puzzling. The phenomenon was noted first in a few of the E series of samples examined by the author in the Scientific Department of the National Gallery, London, using a system of filters that gave selected bands of radiation in the blue to near-ultraviolet wavelength range. Other samples were being simultaneously studied in the laboratory of the National Gallery of Art, Washington, using a different apparatus with filters giving well-defined regions of visible light.[29] When describing the fluorescence occurring in various samples below, it is to be assumed that the exciting radiation is between 450 and 490 nm and the fluorescence was observed at wavelengths greater than 515 nm with results not markedly different to those observed when using ultra-violet light. The fluorescent lines seen, usually between pairs of layers, did not vary much in color from sample to sample or with position in the cross section, being, at the wavelengths stated, a clear yellow, occasionally tending just perceptibly toward greenish or orange.

The first sample in which the phenomenon was noted was EI, *Blue of sky, top edge near left hand corner* (Pl. Ib), in which a thin line of fluorescence followed the orange-brown line that divides the ultramarine sky (since it is the sky now visible, it is assumed to be Titian) from an azurite blue beneath. The brown layer was first thought to be some sort of varnish, but laser microspectral analysis detected a high concentration of iron and the major and minor trace elements associated with ochre pigments. Although it is thin, at high magnification it can be seen to be an opaque paint layer. It was then proposed to examine all the rest of the sections from *The Feast of the Gods* in the same way, and to our surprise, a total of twenty-eight showed a thin line of bright yellow fluorescence between pairs of layers, and three sections displayed two separate fluorescent layers at different levels. The thickness of the line of fluorescence was usually not more than 10 microns, more comparable to that of a varnish layer than of most paint layers.

The phenomenon of fluorescence as it relates to works of art has recently been reviewed very thoroughly by E. René de la Rie.[30] It must be pointed out at once that fluorescence between layers in paint cross sections of what might loosely be termed "Old Master" paintings is not a common occurrence. The writer is more familiar with it in paint sections from polychrome sculptures, which over the centuries have often suffered successive repainting and revarnishing. In such cases the fluorescence, in ultraviolet (or selected wavelengths of visible light), is generally of a translucent, unpigmented film between coats of paint, and these unpigmented films may incorporate varnish, wax, oil, glue, grease, or dirt. Fluorescent layers of this sort usually indicate a time lapse between successive applications of paint, and often varnishing in between. In pictures the most common occurrence is that of a restorer's varnish applied to the surface before retouching, or traces of old varnish left in situ beneath retouching or repaint. Examples from *The*

Feast of the Gods were found in Samples B4, *Orange-brown leaves, top right-hand corner*; T16, *Golden-brown-glazed branch of tree trunk*; and T18, *Rocky cliff face to left of and below ledge on which the tiny stag stands*, all of which had as a top layer a typical restorer's mixture of multicolor pigments containing ochre pigments, black, and a few small rounded blue particles. Beneath this repaint is a line of old varnish that fluoresces similarly to the lines of fluorescence seen between paint layers in a number of cross sections of the painting, as described above.

It cannot automatically be assumed, however, that it is varnish fluorescing between the paint layers in some of the paint cross sections of *The Feast of the Gods*, even though this would seem a likely explanation. A wide variety of materials fluoresce when exposed to ultraviolet or selected wavelengths of visible light, as part of the radiation is absorbed and part reemitted at a different, and longer, wavelength of visible light. Only those materials relevant to paintings need concern us here. Very few pigments exhibit strong fluorescence. Of the pigments identified in *The Feast of the Gods*, lake pigments, both red and yellow varieties, usually fluoresce, and the color of the fluorescence of the former varies from a dull purplish-red to orange, depending on the dyestuff present.[31] A number of organic materials used in paintings fluoresce, particularly when aged. Notable among them are natural (that is, plant) resins, which when dissolved in a volatile solvent or a drying oil are traditionally used as varnishes for paintings. Familiar ones in use, even in modern times, are mastic and dammar; pine resin, sandarac, and others were common ingredients in the past. A freshly applied coat of natural resin varnish does not fluoresce in ultraviolet or blue light. The property develops only with age and degradation. De la Rie associates it with yellowing of materials with age, and indeed, a picture with an old and yellow varnish looked at under an ultraviolet lamp in the course of cleaning is obscured by the milky fluorescence of the varnish except in the cleaned patches. Old varnish left on the surface can be seen in paint cross sections

of samples taken from *The Feast of the Gods* before cleaning (see Pls. 1, 2, 4–6) and can be seen to fluoresce in the appropriate illumination. It is possible to identify or characterize different materials from the wavelength of the light emitted as fluorescence. It is not a practicable proposition in the case of old paintings since not only do they contain mixtures of complex organic compounds, but the chemical composition of the latter changes with age and state of degradation.

Old glue also fluoresces and is usually present at the bottom of paint sections as a component of the ground (in the case of *The Feast of the Gods*, the gesso) and often impregnating canvas fibers. It is possible to identify or characterize different materials from the wavelength of the light emitted as fluorescence.

Some distinctions could be made, however, in the location of the lines of fluorescence within the cross sections. In a few they were associated with the orange-brown layer (found to be an ochre pigment) first seen in the section of Sample E1, *Blue of sky, top edge, near top left corner* (Pl. 1b). So thin as to be almost a line in the cross section of E1, it varies in thickness, and is, in fact, the orange-brown layer close to the surface in some parts of the sky in the upper left corner of the picture, imparting a brownish-pink tinge to the thin and rather worn paint of Titian's sky and clouds.

Of the total of twenty-eight paint sections exhibiting fluorescence between paint layers it was found that in fourteen the line of fluorescence was associated with (a) a thin, pale yellow granular layer, sometimes two successive and similar ones, the upper being often a slightly warmer and more orange color, and (b) a translucent glazelike layer without discernible pigment particles and usually green, greenish-yellow, or brownish-black in color. Certainly, the green glazes are likely, given the date and provenance of the picture, to be of a "copper-resinate" type, and it might be reasoned that it is the resin component of the green glaze (which if it can be detected, has been found to be pine resin) that is the source of the fluorescence, but in practice green copper

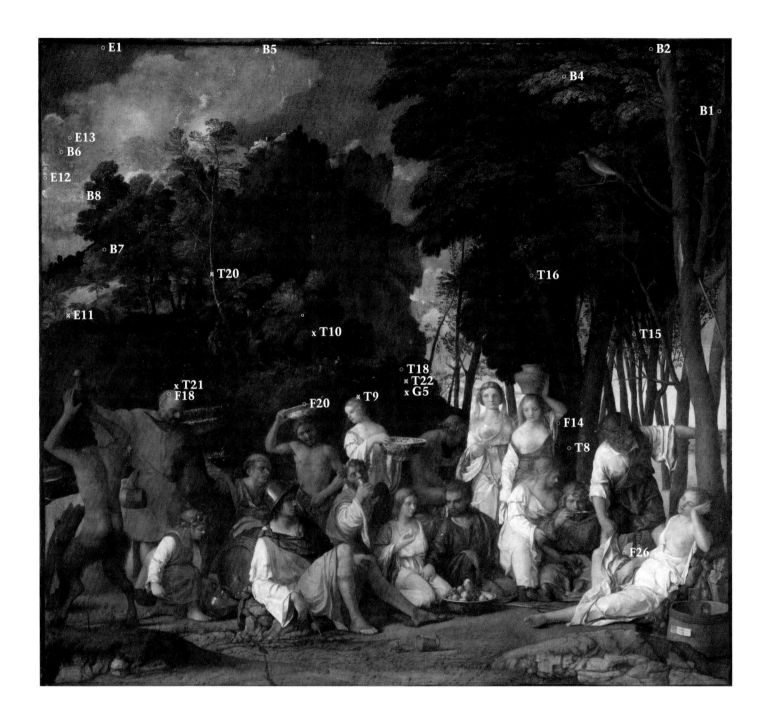

resinate glazes usually look dark under ultraviolet or blue light.[32] In fact, in the fourteen sections in question the fluorescence was not of the green or dark glaze layer itself, but sometimes above it, and usually between it and the associated pale yellow granular layer.

The distribution on the picture surface of samples that showed lines of fluorescence in their cross sections is shown on fig. 39 marked with an "○", while the distribution of samples that have one or more granular yellow layers in their cross sections is marked with an "x" on the same photograph. It must be borne in mind that none of these samples was taken for the express purpose of tracing either the fluorescent layers or the granular yellow layers; they

39. The Feast of the Gods, with location of fluorescence and yellow granular layer

○ *Fluorescence*
x *Yellow granular layer*

happen to have been present at the location of sampling. The plot in fig. 39 does not therefore present a true distribution of either, especially since virtually no samples could be taken from the brown cliff in the center of the picture; it can only give some idea of the extent of distribution.

The pale yellow granular layers associated with the lines of fluorescence are likely to be lead-tin yellow. This was confirmed in the case of the Sample B8, Pentimento *of hidden buildings, top left, under pale blue cloud* (fig. 39). EDX analysis carried out on the paint cross section in the scanning electron microscope identified lead and tin as the principal elements present in the yellow granular layer, a low proportion of silicon indicating lead-tin yellow Type I.[33]

Lead-tin yellow is an opaque pigment, with hiding power as good as that of lead white, and it would be an ideal choice for a painter wishing to obliterate Bellini's tree trunks or any other parts of the landscape, for only a relatively thin coat would be needed. Also, it would form a good underpaint for any subsequent foliage, producing a brilliant green with just the addition of a glaze of copper resinate green. Lead-tin yellow is opaque to visible light and is also as opaque to X-rays as lead white. The thin yellow granular layer seen in the paint cross sections with its rather sparsely distributed grains of pigment could be responsible for the seemingly floating, mistlike patches of white seen above the heads of the figures and among the trees. The distribution on the picture of the samples containing the thin yellow granular layer, or layers, within the limitation of the number of samples possible, suggests that this might be so.

However reasonable this hypothesis with respect to the recurring yellow granular layer, it does not explain the fluorescent line or layer associated with it in fourteen out of the eighteen samples in which it was found, and this topic must be given further consideration. Analysis of the paint medium of samples from presumed Bellini and presumed Titian paint showed both to be walnut oil, and it seems quite probable that the painter of the first alteration to the landscape would also have used a dry-

ing oil, either walnut or linseed. It was also noted that in the early years of the sixteenth century, oil painting, in the sense of using oil medium throughout the picture, was a comparatively new technique. Different pigments absorb different amounts of oil. They dry at different rates when ground with oil to make a paint (for example, lead pigments dry quickly, lakes and carbon blacks slowly), and in the course of drying the surfaces of some colors become matte and dull while others stay glossy. To obviate these difficulties two practices were sometimes resorted to. One was "oiling-out" of the matte or dried-out areas, accomplished by rubbing into the surface a little drying oil (linseed or walnut oil with a siccative to hasten drying), then carefully rubbing off the surplus with a rag. Early documentary sources warn against leaving excess oil as it might yellow with time.[34] An alternative practice was that of applying an intermediate varnish (a "retouching varnish"), either selectively to the matte or dry areas or over the whole surface of the picture.[35] The extent to which these practices were followed is not known. Literary sources suggest them to be more prevalent in the eighteenth and nineteenth centuries than earlier. Selective oiling-out or varnishing would explain the presence of a fluorescent layer between Titian's repainting of the sky and the landscape or sky beneath, and between Bellini's paint layers and those above. The possibility has also to be considered that the picture might have received an all-over coat of varnish at some time after Bellini had completed it and perhaps again after the first alteration to the landscape by the second painter.

If an all-over varnish had been applied to the painting after Bellini had finished his work, then it might be expected to show itself as a fluorescent line or layer in a higher proportion of samples from the landscape background. The same would apply to an all-over varnish between the first alteration to the landscape and Titian's paint. Selective varnishing or oiling-out would account for the presence of lines of fluorescence in sections of samples only from certain areas. In the case of the fluorescent line associated with the yellow

granular layer and green or dark glaze, a reasonable explanation might be that the painter of the first alteration varnished or oiled-out the surface of the yellow granular layer (which, in the nature of lead-tin yellow, would have been rather matte and dry) before applying a green or dark glaze. The other possible explanation would be the presence of a layer or component of yellow lake pigment that, by itself, fluoresces, but this would not explain the presence of fluorescent lines or layers associated with the yellow granular layers in the absence of a glaze.

Whatever the reason for the lines of fluorescence between the paint layers in the cross sections, it seems likely that they represent some interruption in the work on the picture. It is worth noting that the rather rare phenomenon of a fluorescent layer between paint layers in the work of a single artist was found when the fragments of panels of a Dosso Dossi ceiling painting were examined at the National Gallery, London. The ceiling painting, which was on wood, was painted for one of the other *camerini* at Ferrara. A clear, unpigmented layer, like a varnish, was found between the ultramarine paint of the blue sky and brown paint layers beneath, which fluoresced strongly under ultraviolet.[36]

Using such recurring paint layers or features as those described above as guidelines or benchmarks, an attempt was made to interpret the paint samples and their cross sections in terms of the order of painting of the landscape background.

The Central Band of Landscape and Sky between and above the Heads of the Standing Figures; the Bellini "Sunset" Sky and Distant Blue Hills

The presence of the Bellini sky, which appears in the radiograph as a dense area between the tree trunks, could be firmly established from the paint cross sections. It consists of a layer of lead white, of moderate thickness, very faintly tinted pink with the addition of a little extremely finely ground vermilion, only a few particles of which are large enough to be seen on the photomicrographs at about 200x. This pinkish-cream layer of Bellini sky was identified in samples going across the picture from just above Silenus' head (Sample F18) to the opposite (that is, righthand) edge of the canvas. It is as a rule directly on the white priming. In Sample T4 (Pl. 4b), *Second tree trunk from right, from where paint of edge of trunk has been extended over sky*, it can be seen under typical Bellini tree trunk paint, the tree trunk having been painted in after the sky had been completed, in the usual Bellini manner. Neither of the alterations to the landscape has obscured the small area of Bellini pinkish-cream sky in the gap between the trees above Pan's head and framing the heads of the two nymphs on the right, apart from the addition of some of the brown, or rather browned, leaf sprays, which from their technique and style could well have been added by Titian. Pl. 5a shows a cross section of Sample T13, *Sky between thin tree trunks above Pan's head, with streak of brown(ed?) foliage.* In this case the pinkish sky (iv) is over a layer of Bellini tree trunk paint (iii); above it is a blue layer of lead white and azurite (v), which forms a blue streak across the sky. The blue streak looks as if it has been painted wet-in-wet on the pink sky, and there seems no reason to doubt it is by Bellini. Above the blue streak is a very thin green paint, brownish toward the surface (a discolored varnish, which gives strong fluorescence, separates the browned green of the leaf from a thin bluish retouching on top; both varnish and retouching have been removed in the recent cleaning). An unusual feature of Sample 13 is that the pinkish sky is over Bellini tree trunk paint, instead of under. The reason seems to be that there are a number of slender sapling tree trunks and branches in the area, and yet another group seen in the X-radiograph between the large tree trunks to the left of Pan. From their lower density on the radiograph the latter might be judged to be painted on the sky and not on areas left in reserve. It was probably easier for the artist here to leave only the largest tree trunks in reserve, paint the pink sky between them, and add the subsidiary saplings and branches on top of it.

On the far right the color of the band of

sunset sky subtly changes from pinkish-cream to yellowish-cream. From examination of the paint surface and of a cross-section of a sample it can be seen to have been repainted. The Bellini sky beneath is still the same pale pink, while the layer above is of a cream color, the paint of which under the microscope consists of lead white in which are patches of what looks like lead-tin yellow. The repainting of the sky is very similar to that on the yellow-green landscape around the satyr at far left, with the same rather pastose quality, and brushmarks evident where it goes round the contours of the forms of figures and tree trunks, sometimes overlapping, sometimes skirting them. There is no sign of interruption between the two layers, no translucent layer representing varnish or oiling-out, no dirt. Since, though, repainting would have been virtually just putting one coat of lead white on top of another, oiling-out or intermediate varnishing would probably not have been required. Hence it seems impossible to say with certainty whether this repainting of the sunset sky on the far right was by Bellini himself, by the painter of the intermediate landscape, or by Titian. Whoever added the upper cream-colored layer to the sky on the far right may also have been responsible for infilling the small patches of sky seen between the hanging braids of hair and the neck and shoulders of the nymph with the orange dress.

Higher up on the picture, on the X-radiograph, is a hard straight line delimiting the top of the opaque band of sky seen through the tree trunks. It even makes a slight ridge on the surface of the picture. The opaque paint of the sky can be seen in the X-radiograph to go round and not cut across the spaces reserved for the tree trunks. At just above the level of the fork of the enormous Bellini tree visible on the picture itself at the far right, the color of the sky changes from pale pinkish-cream or pale yellowish-cream to blue. One supposes that in making that transition Bellini adopted the method of overlapping one band of color on top of the other and it may be this overlap which causes the hard horizontal line. There are in fact two layers of blue. The first layer, directly on the priming, and

therefore Bellini, is of azurite and lead white and rather thick. The second, which is what we now see, is a thinner coat of ultramarine and lead white. This repainting of the blue seems to be the equivalent of the repainting of the pinkish-cream sky lower down. Again, we have no evidence that it is not Bellini's work. Both azurite and ultramarine have been identified in skies in his pictures and azurite was sometimes used as under paint for the rather more expensive ultramarine.

The blue distant hills on the horizon are painted partly on the pale green of the landscape and partly on the pinkish-cream sky. Glimpses of them could be seen in small losses right across the picture. Even the left elbow of the satyr at the far left (Pl. 3b, Sample E10b) shows a thin blue layer under the flesh, which may represent a continuation of the blue distant landscape; it is at the same level as the hills at the far right. The order of painting here is interesting. The blue of the hills can be distinguished under the dark repaint around Pan's face and arm, though he himself is painted directly on the white priming. However, Bellini has carried on the line of distant hills *across* the reserved spaces left for the big tree trunks between Priapus and the nymph with the jar on her head, and the blue hump of a hill appears as a pentimento under the Bellini tree trunk next to Priapus' proper right shoulder, and also on the X-radiograph. The hills themselves have a pale blue underpaint with a thin dark glaze of large, intensely blue ultramarine particles. This can be seen in Pl. 5b, Sample F16, *Revealed blue distant hills on far right-hand side of nymph with jar on her head* (the sample was taken from where some dark green repaint remained).

Still pursuing the topic of the Bellini sunset sky, but turning our attention now to the hidden region behind the heads of the standing figures to the left of Pan, yet another recurring paint layer was found in the paint cross sections, the so-called "purple" layer, mentioned earlier in this report. The recognizable features are the presence of both azurite and red lake particles (often very few of the latter) in an opaque grayish-fawn granular matrix, and in a few samples (T20, T21, and G5, Pl. 5d)

PLATE 1 Preliminary samples, series E (before cleaning), from edge of picture

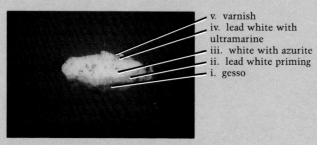

v. varnish
iv. lead white with ultramarine
iii. white with azurite
ii. lead white priming
i. gesso

a. Sample E5, *Blue sky between tree trunks, near right-hand edge of picture, from below end of handle of scythe*

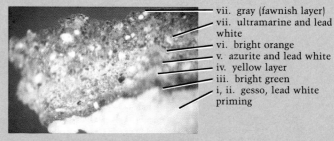

vii. gray (fawnish layer)
vii. ultramarine and lead white
vi. bright orange
v. azurite and lead white
iv. yellow layer
iii. bright green
i, ii. gesso, lead white priming

b. Sample E1, *Blue sky, top edge, near left-hand corner*

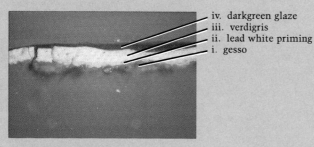

iv. darkgreen glaze
iii. verdigris
ii. lead white priming
i. gesso

c. Sample E7, *Yellow-green grassy foreground, along lower edge of picture*

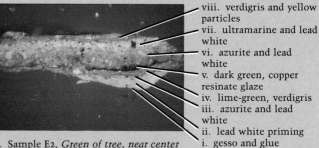

viii. verdigris and yellow particles
vii. ultramarine and lead white
vi. azurite and lead white
v. dark green, copper resinate glaze
iv. lime-green, verdigris
iii. azurite and lead white
ii. lead white priming
i. gesso and glue

d. Sample E2, *Green of tree, near center of top edge where foliage meets sky*

e. Sample E11, *Paint loss in meadow with staghunt; upper left of picture. Site of Sample E11. (photomicrograph of surface, 10x)*

ix. opaque lead tin yellow and lead white
viii. granular yellow with orange
vii. green glaze
vi. azurite and lake pigments in green matrix
v. semitransparent glaze
iv. yellow-green
iii. gray with vermilion
ii. lead white priming

f. Sample E11, *From islet of surviving paint within paint loss in meadow with staghunt (photomicrograph of paint cross section; 220x)*

PLATE 2 Drapery of Figures

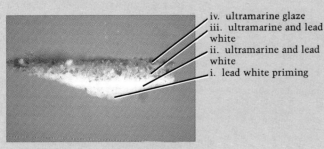

iv. ultramarine glaze
iii. ultramarine and lead white
ii. ultramarine and lead white
i. lead white priming

a. Sample F23, *Blue of Bacchus' dress, from small loss in skirt between knee and ankle of proper right leg*

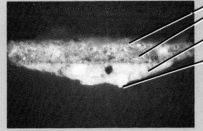

v. ultramarine glaze
iv. ultramarine and lead white
iii. lake pigment and ultramarine in lead white
ii. lead white priming

b. Sample F24, *Blue dress of nymph with bowl, from small loss on skirt, just below hip level.*

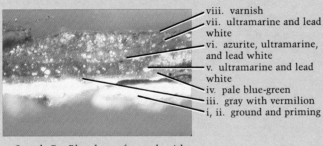

viii. varnish
vii. ultramarine and lead white
vi. azurite, ultramarine, and lead white
v. ultramarine and lead white
iv. pale blue-green
iii. gray with vermilion
i, ii. ground and priming

c. Sample F2, *Blue dress of nymph with jar on head, from just above proper left breast and above F1*

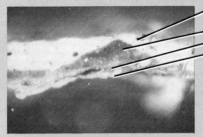

v. vermilion and lake particles in lead white
iv. gray-blue opaque
iii. gray with vermilion
i, ii. gesso and lead white priming traces

d. Sample F1, *Proper left breast of nymph with jar on head; from pentimento of blue drapery just below F2*

iii. ultramarine and lead white
ii. lead white priming

e. Sample F25, *Blue of Apollo's tunic, from left-hand side of his chest*

v. lake particles, vermilion and lead white
iv. crimson glaze
iii. lake particles and lead white
i, ii. gesso and lead white priming

f. Sample F11, *Pink of Cybele's dress, from highlight on fold near her waist*

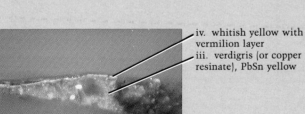

iv. whitish yellow with vermilion layer
iii. verdigris (or copper resinate), PbSn yellow

g. Sample F12, *Red highlights of Priapus' green- and red-shot drapery, from his right thigh*

v. orange (realgar and orange-red ochre)
iv. orange (orpiment and realgar)
iii. gray
i, ii. gesso and priming

h. Sample F8, *Silenus' orange robe, from swag of sleeve over ass' flank*

PLATE 3 Flesh of Figures

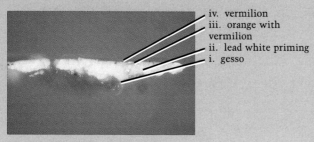

iv. vermilion
iii. orange with vermilion
ii. lead white priming
i. gesso

a. Sample F30, *Flesh of satyr, extreme left, from middle tone of back, waist level*

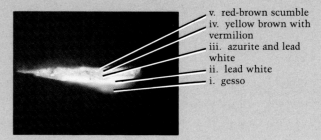

v. red-brown scumble
iv. yellow brown with vermilion
iii. azurite and lead white
ii. lead white
i. gesso

b. Sample E10b, *Elbow of satyr, extreme left*

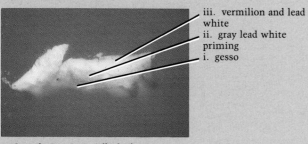

iii. vermilion and lead white
ii. gray lead white priming
i. gesso

c. Sample F21, *Lotos' flesh, forearm near elbow.*

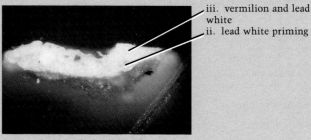

iii. vermilion and lead white
ii. lead white priming

d. Sample F22, *Flesh of nymph with braided hair, from small loss on chest*

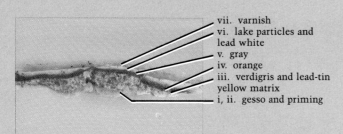

vii. varnish
vi. lake particles and lead white
v. gray
iv. orange
iii. verdigris and lead-tin yellow matrix
i, ii. gesso and priming

e. Sample F7, *Pink of Silvanus' robe with slight crimson glaze, from edge of loss, can be seen to be painted over green*

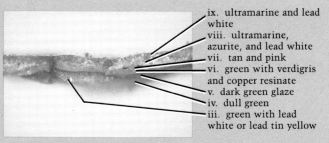

ix. ultramarine and lead white
viii. ultramarine, azurite, and lead white
vii. tan and pink
vi. green with verdigris and copper resinate
v. dark green glaze
iv. dull green
iii. green with lead white or lead tin yellow

f. Sample F26, *Blue of Apollo's sleeve, left arm holding* lira da braccio

PLATE 4 Bellini tree trunk paint

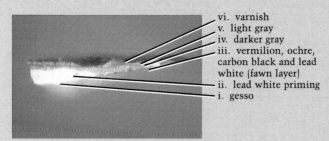

vi. varnish
v. light gray
iv. darker gray
iii. vermilion, ochre, carbon black and lead white (fawn layer)
ii. lead white priming
i. gesso

a. Sample T3, *Center of second tree trunk from right, from just above Priapus' arm*

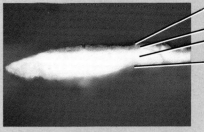

v. blackish brown with vermilion
iv. gray with vermilion
iii. cream color with vermilion
ii. white priming

b. Sample T4, *Second tree trunk from right, but where edge of trunk extended over cream-colored sky*

c. Sample E3, *Brown tree trunk top right-hand corner; top surface of unmounted sample, 110x*

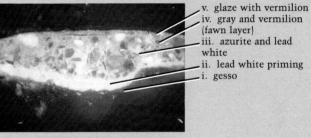

v. glaze with vermilion
iv. gray and vermilion (fawn layer)
iii. azurite and lead white
ii. lead white priming
i. gesso

d. Sample E3, *Brown of tree trunk, top right hand corner*

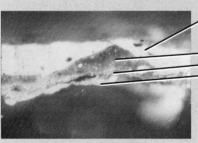

v. lead white, vermilion and lake particles (flesh paint)
iv. gray-blue
iii. gray with vermilion
i, ii. gesso and white priming

e. Sample F1, *Proper left breast of nymph with jar on head, from pentimento of blue drapery just below F2*

iii. gray, vermilion, and azurite
ii. verdigris in lead white or lead tin yellow (?)
i. gesso

f. Sample F28, *Stump of tree, lower left corner*

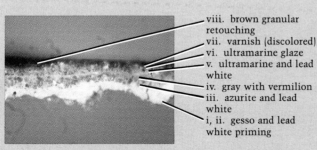

viii. brown granular retouching
vii. varnish (discolored)
vi. ultramarine glaze
v. ultramarine and lead white
iv. gray with vermilion
iii. azurite and lead white
i, ii. gesso and lead white priming

g. Sample B3, *Patch of ultramarine sky, close to (Bellini) tree trunk top right corner*

vii. deep green with yellow particles
vi. granular pale yellow layer in green matrix
v. green glaze and red lake pigment
iv. gray with azurite and pale yellow granules (fawn layer)
iii. gray with vermilion (fawn layer)
ii. lead white priming
i. gesso

h. Sample T22, *Background foliage to left of and above Pan's head, top layer of dark brown*

PLATE 5 Middle landscape, behind and above figures

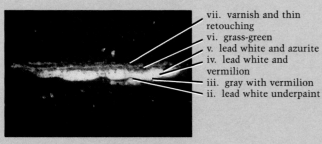

vii. varnish and thin retouching
vi. grass-green
v. lead white and azurite
iv. lead white and vermilion
iii. gray with vermilion
ii. lead white underpaint

a. Sample T13, *Sky between trees above head of Pan, with sheaf of browned foliage*

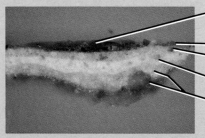

vi. azurite, vermilion, and lake particles in a green matrix
v. ultramarine
iv. azurite and lead white
iii. pale lime-green (verdigris ?)
i, ii. gesso and whitish priming

b. Sample F16, *Revealed blue distant hills on right-hand side of nymph with jar on head*

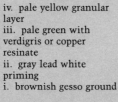

c. Sample G5, *Bush revealed by cleaning. Reverse of unmounted fragment.*

v. brilliant green
iv. green glaze
iii. azurite and lake pigment ("purple")

d. Sample G5, *Bush revealed by cleaning cross section of same fragment as fig. c*

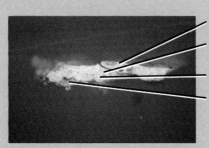

iv. pale yellow granular layer
iii. pale green with verdigris or copper resinate
ii. gray lead white priming
i. brownish gesso ground

e. Sample F17, *Green blue patch of sky adjacent to unmounted scraping by transmitted light*

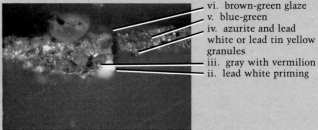

vi. brown-green glaze
v. blue-green
iv. azurite and lead white or lead tin yellow granules
iii. gray with vermilion
ii. lead white priming

f. Sample T21, *Blue-green of stream above Silenus' head*

ix. putty or repaint scrap
viii. blue green
vii. leaf green layer
vi. pale yellow opaque granular layer
v. moss-green glaze
iv. deep green glaze
iii. lead white and lead-tin yellow with verdigris and azurite

g. Sample T9, *Dark green background foliage, just above head of nymph with bowl*

h. Sample T9, *As fig. g, but in flourescent conditions (lambda 500 nm)*

PLATE 6 The upper landscape background

ix. yellow glaze
viii. lead white and lead-tin yellow with lake and azurite particles
vii. opaque "murky" green with yellow pigment
vi. granular orange-yellow (lead-tin yellow ?)
v. copper resinate glaze
iv. granular yellow-green layer with verdigris or copper resinate
iii. azurite crystalline particles in a matrix of fine yellow granules

a. Sample T20, *Yellow of tree trunk, as in T19, above small satyr disappearing into underground*

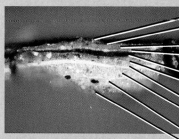

xiii. brown-green layer
xii. opaque yellow particles
xi. yellowish green
x. granular orange-yellow
ix. black line
vii. red lake, vermilion, white, yellow, and green
vi. pale pink
v. pale grass-green (verdigris)
iv. buff yellow
iii. gray with azurite (fawn layer)

b. Sample T10, *Brown-green foliage above satyr with dish on head, from vertical seam in canvas*

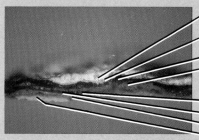

ix. lead tin yellow and lead white
viii. thin granular yellow-gray
vii. yellow-green glaze
vi. azurite and lake particles in greenish matrix
v. deep green glaze
iv. thin yellow-green
iii. gray with vermilion
ii. lead white priming

c. Sample E11, *From islet of surviving paint loss in meadow with staghunt (photomicrograph of paint cross section; 220x)*

d. Sample E11, *As c, but showing flourescence between layers under visible light (lambda 400 nm)*

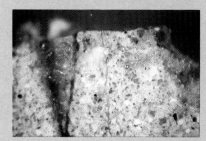

e. Sample B6, *Dull pink cloud, left-hand edge; top surface of unmounted fragment*

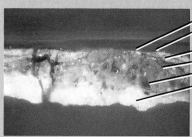

vii. old varnish
vi. ultramarine, azurite, and lead white
v. orange-yellow
iv. yellow granules
iii. azurite in lead white
i, ii. gesso and lead white priming

f. Sample B6, *As e, but cross section of same fragment*

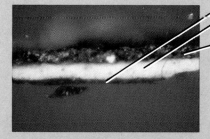

iii. gray and vermilion
iv. white with blue and red particles
v. yellow brown ochre, azurite and white

g. Sample T16, *Golden brown glazed branch of tree trunk*

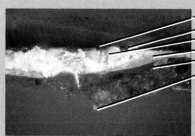

viii. old varnish
vii. golden-brown glaze
vi. lead-tin yellow
v. gray and vermilion
iv. deep green
iii. vermilion and gray

h. Sample B1, *Brown "Titian-type" leaves over Bellini tree, upper-right corner*

some fine yellow granules of the type that form the "granular yellow layers" (q.v.) are also present. Whereas ultramarine mixed with crimson-colored lake pigments gives pure violet colors, azurite, being just on the green side of blue, produces slightly duller and more brownish purples, an effect that would be increased by the presence of the grayish-fawn matrix. It seemed reasonable to suppose that the "purple" layer might correspond to brownish-mauve streaks on the Bellini pinkish-cream sunset sky. Purplish streaks of this sort can be seen, for example, on the pale sky of *The Resurrection* (Staatliche Museum, Berlin) and of *The Baptism of Christ* (Church of Saint Corona, Vicenza). The hypothesis that the purple layer might be original seemed to be supported by the fact that six out of a total of eight of the paint sections in which it occurred were taken from just above the heads of the foreground figures, in a line running roughly from the top of Silenus' head to the top of Pan's head, where Bellini pinkish-cream sky is known to lie beneath the dark repaint. The two remaining samples, T10 and T20, in which the purple layer occurs, are from higher up on the left, but it is just possible that the original Bellini composition might have featured a patch of sky higher up among the trees on the left. Unfortunately, in T10 and T20 the gesso and priming layers are missing (the "purple" layer is the lowest surviving one), so it is impossible to see if blue or pink Bellini sky exists beneath. Examination of the paint sections with the "purple" layer under fluorescing conditions revealed a very thin fluorescent line between the purple layer and either the Bellini sunset sky or Bellini tree trunk in four of the sections. This raises the suspicion that the "purple" layer is one of the earliest repaints, perhaps by a painter who found the straight strip of Bellini sky uninteresting and wanted to enliven it. The "purple" layer can be seen in Pls. 5c and d, Sample G5, *Bright blue-green bush revealed by cleaning, above bowl of nymph, center,* Pl. 5f, Sample T21, *Blue-green of stream above Silenus' head,* and Pl. 6b, Sample T10, *Brownish-green foliage above satyr with dish on his head; from vertical seam in canvas where paint very thick.* If

the "purple" layer is not Bellini, the inference is that all layers above it must be by a later hand.

Meanwhile the cleaning of the picture was progressing with the gradual removal of a good deal of overpaint and old retouching, and particularly of the sandy-looking brown paint that had been spread so liberally over the picture to disguise its inequalities and the inadequacies of the repairs and retouchings. It gradually became evident that there was something incongruous about the very thick formless tree trunk, or trunks, just to the right of the upraised elbow of the nymph with the jar on her head. In contrast to the beautifully modelled grayish-brown trunks of the Bellini trees to the right, its form was meaningless and it was blackish green in color. In the X-radiograph it can be seen that in Bellini's original composition the dark green tree trunk as such did not exist. There was a tree trunk just behind the nymph that looks almost to be growing out of the pot on her head. Between it and the one to the left of Priapus' shoulder was a V-shaped gap through which the sky and distant hills could be seen, in the middle of which was a smaller tree trunk. The V-shaped gap continued downward below the nymph's elbow, and in the X-radiograph the form of Bellini's blue hill can be seen near the bottom. In removing the "Camuccini-type" overpaint David Bull revealed this small vertical strip of Bellini sky and distant landscape. It still had remains of some blackish-green paint on it, and, as he has described, evidently a previous restorer had cleaned down, probably finally with scraping, to discover this bit of hidden Bellini, and then decided to cover it up again.[37] Pl. 5b, Sample F16, *Revealed blue distant hills on right-hand side of nymph with jar on head*, was taken from a spot where there was still a little of the dark green paint which the previous restorer had incompletely removed. The section shows the pale green of the Bellini distant landscape on the priming followed by the pale blue underpaint of the distant hills and a final dark, almost blackish, glaze containing large intensely blue ultramarine particles. On top of the Bellini glaze is a turbid-looking blue-green layer

in which can be made out some large blue azurite particles. A scraping from the same spot revealed this dark green glossy paint to consist of a translucent matrix of copper-resinate type, packed with blue azurite particles and with the occasional globule of red lake pigment; the latter glowed a dull purplish-red in fluorescent conditions. It was the "green-blue-and-red" paint mentioned earlier. It was to prove another "benchmark." David Bull has described how there is visible around quite a considerable surrounding area, the boundary showing the extent of the action of some cleaning solvent or reagent, which has removed upper paint layers in the region, including presumably Titian's. The exploratory activities of the earlier restorer (whom David Bull convincingly identifies with Camuccini) were not confined to the excavation of the narrow strip of Bellini distant landscape below the nymph's upraised arm, but he must have lost his nerve and left the glossy green covering the Bellini tree trunks and distant landscape. In the course of removal of the "Camuccini" brown overpaint it was discovered that the glossy dark green on the tree trunk continues up into the foliage of the trees to about two-thirds of the height of the picture and its surface is at a lower level than the dark paint of the surrounding foliage. Higher still a Bellini gray-brown branch of the same tree was disguised with a golden-brown glaze in an attempt to make its junction with the green tree trunk less awkward (Sample T16). It was earlier noted that a sample for medium analysis, M5, was taken from the green of the tree trunk just below T16 before all later restorations had been removed. The sample was also analyzed for pigments, and showed a high concentration of copper from green and blue copper pigments present as well as a few small, brilliant green particles of viridian (transparent chromium oxide, chromium being confirmed by laser-microspectral analysis). This pigment must have been present in a later restoration than Camuccini's, for it was not discovered as a chemical compound until 1838 and not available as an artist's pigment until 1862 (Vincenzo Camuccini died in 1844). The viridian was probably in the retouching of

a more recent restorer who was unhappy with the appearance of the tree trunk. The so-called "green-blue-and-red" layer (the pigments being in that order of diminishing proportion), *alias* the glossy dark green paint covering the Bellini tree trunk described above, was identified microscopically in cross sections of thirteen samples. Of these, seven (F13–F16 and T7–T9) were in the region of the green tree trunk described above, and taken specifically for the purpose of investigation of overpaint. In those the "green-blue-and-red" layer, which in the area in question is the uppermost surviving layer of the sixteenth-century paint, covers either Bellini tree trunk or Bellini distant landscape or sky. The same glossy dark blue-green can also be recognized in patches around the head of the nymph with the bowl where upper layers have been cleaned away or flaked off. In Sample F18, a small vertical strip of smooth mid-brown paint above Silenus' head (which seems at a lower level than the surrounding paint), the "green-blue-and-red" paint is directly on Bellini pinkish-cream sky, and quite near the picture surface, having above it only a further green glaze and brown ("Camuccini-type") overpaint. There seems a likelihood of sixteenth-century paint layers having been removed from this area also.

Although the sequence of layers often cannot be completely followed through from cross section to cross section (partly because of the absence of the lowest layers (gesso, priming, or recognizable Bellini paint) in some of them, it does seem from Samples F13, 15, 16, and 18, T7, and T8, that, apart from the "purple" layer, which may just have been streaks to embellish the Bellini sky, the "green-blue-and-red" mixture was the first coat used to cover the Bellini sky, distant hills and at least some of the tree trunks. This is contrary to our initial hypothesis, which was that an opaque paint like lead-tin yellow or lead white would have been used. The "green-blue-and-red" layer must then form part of the first alteration to the landscape. Where it is not exposed by earlier cleaning (on and around the green tree trunk), it is above the Bellini sunset sky and the "purple" layer where that exists, and generally be-

low the yellow granular layer and its associated green glaze and line of fluorescence (in T9 there are rather similar green layers below and above a fluorescent line separating as usual a thin green glaze from the yellow granular layer above). The repetition of this combination of rather unusual layers (the "purple" layer, the "green-blue-and-red" and the yellow granular layer accompanied by a line of fluorescence and frequently also by a thin green or dark glaze), even though not always all present at once or exactly in the same order, suggests that they belong to the same intermediate stage of the painting. They appear together mainly in the middle band of landscape behind and above the heads of the figures to the left of Pan where Bellini tree trunks, distant hills, and sunset sky disappear behind overpaint. The writer tentatively offers the following as one possible explanation for these rather strange combinations of pigments and layers. It has been noted that materials used in greens for foliage were strictly limited and the color could generally only be varied by altering the proportions of the few possible ingredients, or more frequently by building up in a series of semi-transparent layers.[38] The incorporation of azurite into a copper-resinate type green glaze would give a deep blue green, and the addition of a little red lake pigment would serve to "dirty" the color, as it were, making it darker while still retaining its translucent glazelike character. As a glazing pigment, azurite, though appearing as clear blue crystalline fragments under the microscope, has a rather high refractive index, which implies that (unlike ultramarine or lake pigment) the boundaries of the particles would be perceptible in a film of oil medium. It may be recalled that one of the constituents of the medium from a sample that certainly included some of the glossy green from the trunk (Sample M5) was deduced to be pine resin, which is the resin that has most often been detected in green copper-resinate type glazes. A high proportion of resin to oil in the green glaze would raise the refractive index of the medium above that of oil and might help to explain why the azurite particles are difficult to discern in the layer under the microscope by reflected

light, but show up well in a thin sample by transmitted light by reason of their blue color. The red lake particles present are best detected by their reddish-purple fluorescence under ultraviolet or blue visible light. A higher proportion of pine resin in the medium would also be likely to increase the gloss, and indeed the dark green paint on the green tree trunk was very glossy by comparison with either the Bellini or Titian paint in the picture when the latter was in an unvarnished state. The presence of a rather unusually high proportion of resin component might also explain David Bull's observation that the glossy green paint of the tree trunk was rather more vulnerable to cleaning solvents than would be anticipated for a picture of this type and period, so that at one stage it was suspected it might have been restorer's repaint. It may be that whoever uncovered the narrow strip of Bellini landscape and sky below the nymph's arm, in using an active solvent to do so, may have caused the dark green paint film to swell and weaken, which would make it more vulnerable to solvents applied later. The painter of the intermediate landscape may have discovered that, although dark in color, the "green-blue-and-red" layer was not sufficiently opaque to hide the row of Bellini tree trunks after all, and put over it, almost as a thin scumble, the granular yellow layer, afterwards giving a final green copper resinate glaze of the usual sort.

Both the "purple" layer and the "green-blue-and-red" layer had relevance to another discovery made by David Bull while removing other restorers' dark repaint. This was the uncovering of the vivid green bush just behind the nymph holding the bowl. Pl. 5c shows Sample G5, *Bright blue-green of bush revealed by cleaning; above bowl of nymph, center.* 5c is a photomicrograph of the reverse of the unmounted paint fragment by reflected light and 5d the cross-section of the same paint fragment. Each shows as the bottom layer a trace of Bellini tree trunk paint (the tree trunk seen in the radiograph just behind and above the nymph's bowl); (ii), the "purple" layer, which also has a few fine yellow particles similar to those of the yellow granular layer; (iii), the "green-blue-and-red" paint;

(iv), a thin yellow-green granular layer; (v), a thick blue-green opaque layer that represents the green bush. In this case, however, the only line of fluorescence was a very thin one between the Bellini tree trunk paint and the "purple" layer. One of the most complicated and perplexing samples is T10, *Brownish-green foliage above satyr with dish on his head, from vertical seam of canvas where paint very thick*, of which a cross section is shown in Pl. 6b. It does repeat some of the layers already cited but has no fewer than ten paint layers (beside the ground and priming, which are missing). It has an extra layer (iv) of thin pale pink, which appears only in one other section, T18. The latter, removed when there was still much brown repaint on the picture, was labelled "rocky cliff face to left and below ledge on which tiny stag stands," but can now be seen to be the dark rear part of the brilliant green bush recently uncovered. There are close similarities in the layer structure of T18, G5 from the green bush itself, and T10, which is some way up on the left and where bushes of similar form can be dimly seen under dark overpaint. The green and brownish layers of T10 above the fluorescent line could be attributed to Titian perhaps. The bottom layer of T10 looks very like the "purple" layer described as directly on top of the Bellini sunset sky, but in some samples with a very fine line of fluorescence between. The same coarse, intensely blue azurite particles in a fawnish matrix, but only a single particle of red lake pigment, is visible. It is similar to the paint of some small, dark turquoise-blue patches among the foliage of the trees (quite unlike Titian's ultramarine patches of sky), which lie at a lower level than the surrounding leaves.

The Upper Landscape Background and Titian's Contribution

Moving upward to the horizontal band of landscape and sky, which starts about at the level of the meadow with the stag hunt, we reach the part of the picture where Titian's intervention is well-established both on historical and stylistic grounds.

Two visible tree trunks that seemed not to be typical Bellini were investigated. The first, the branch coming out of the top of the green-painted tree trunk on the right, has already been discussed and was simply a genuine Bellini tree branch disguised with a golden-brown glaze of the Camuccini type. The other is the slim, tall, pale yellow tree trunk on the upper left, rising out of the ground just near the little satyr who swings through the branches. From the freedom with which it is painted and the rather rich impasto of the paint, one might guess it to be a Titian addition. Sample T19a (Pl. 6a), *Yellow of tall slender tree trunk upper left*, showed all layers from the ground upward. (iii) and (iv) are each layers of Bellini tree trunk paint, or perhaps a branch as seen on the X-radiograph, (v) is a green blue, perhaps Bellini foliage. Above this (vi) is a horizontal cleavage filled with translucent dark material that fluoresces strongly when irradiated in the usual way, then (vii) the dark azurite-packed layer like the patches of sky just described. Finally, (viii) is a moderately thick, compact cream-colored layer, the tree trunk which could be by Titian, though it also was covered with the Camuccini-type granular-brown incrustation.

The most informative sample from this region proved to be one of the first taken, E11, *Green of meadow, top left, with stag hunt*, already illustrated in Pl. 1e and f, but here shown again with another photomicrograph taken with visible blue light to show the fluorescence between two pairs of layers. (Pls. 6c and d). 6c is a photomicrograph of the cross-section by ordinary reflected light, and 6d of the same section by light of wavelength 500 nm showing lines of fluorescence. The gesso ground (i) is missing, but there is a trace of white priming (ii). On this (iii) is a thin layer of gray Bellini tree trunk paint with the unmistakable tiny vermilion particles, and (iv) a typical yellow-granular layer followed by (v) a yellow-green glaze along which runs a line of fluorescence, visible in the fluorescence photograph. Above this line of fluorescence is (vi), a thin layer of large azurite particles in a greenish matrix that also contains some lake pigment, which seems to have affinities both with the "purple" sky and the "green-blue-and-red" layer,

plus (vii), a very deep green glaze, and (viii), a thin gray-green layer. A second line of fluorescence follows, and finally (ix), the thick yellow-green paint with gray-green inclusions of Titian's meadow. It might be surmised that layer (iv), the thin yellow granular layer, was applied to hide the Bellini tree trunk or branches and was then glazed with green to form part of the landscape, the green glaze either fluorescing of itself or on account of some intermediate varnishing or oiling-out of the yellow granular layer. The painter of the first alteration then put on top (instead as has often been noted, its being beneath), the "green-blue-and-red" layer, with an additional green glaze (with which it has been encountered elsewhere) and a further gray-green layer. Titian's paint is above the second fluorescent line, which may represent his intermediate varnishing or oiling-out. Here Titian seems not to have used an opaque obliterating layer like the orange-brown paint under the sky, but there would be no need if he was painting an opaque yellow-green layer over another of pale green.

A fairly high proportion of samples were taken from the edges of the picture. This is useful as there are often losses or damages round the edges of which small flakes can be got without encroaching on the main area. It has its hazards, however. Care must be taken to detect and avoid old repaints and retouchings (as can be seen from the confusion which arose with results of medium analysis). Another misleading factor is that in working on the picture, the artist may not take the brushstrokes of every one of his layers right up to the edge of the canvas. Nevertheless, some useful results were obtained.

Turning to the topmost part where we come to what has been accepted always as Titian sky and foliage, Samples E2–E5 inclusive, B2 and B3, T13–T15, G2, and G4, all from along or near the top edge from under the frame, all have an azurite/lead white layer of sky painted directly on the white priming, which can be taken to be Bellini sky, while in Sample E1 the first layer on the white priming is a thin green paint, which must be Bellini foliage (this is also the case with Sample E2 (see be-

low), which is from the center of the top edge. It looks, then, as if Bellini in his original composition had an azurite blue sky above and among the tops of his trees, though near the top left corner (E1) and in the center, foliage must have reached the extreme top edge (E2).

Sample E2 (Pl. 1d) has three separate layers of blue. There is a trace of Bellini azurite sky and green foliage paint, then a dark line that shows fluorescence in the usual conditions, above which the two layers of blue (the lower azurite, the upper ultramarine), with green on top, which we presume to be Titian foliage. The ultramarine layer looks almost as if it were painted wet-in-wet on the azurite layer. The color and particle distribution of the upper azurite paint seems to differ slightly from the Bellini blue sky layers and contains one or two prominent dark red lake particles. Even if the azurite layer is the hand of the intermediate painter, Titian would not have needed an opaque obliterating layer before painting his ultramarine sky; the blue beneath would have served as an excellent underpaint. Sample B3 (Pl. 4g) was from a patch of ultramarine sky seen between the leaves to the left of the tallest tree trunk at the far right, very similar to the patches Titian used in *Bacchus and Ariadne* to brighten and open up the mass of foliage. The section shows the edge of a Bellini tree on top of Bellini azurite sky, with Titian ultramarine sky over it. At the start of the investigation it seemed a naive idea that the Bellini sky might be azurite and the Titian one ultramarine, but no layer of ultramarine paint of the sky can be securely assigned to Bellini, only the blue hills of the distant landscape on the horizon. Perhaps Bellini did not wish to detract attention from the splendid blues of the dresses of the figures by using ultramarine in the sky, and perhaps after all Titian was referring to *The Feast of the Gods* when he reminded Tebaldi, the Duke of Ferrara's agent that "there remained to be given a little blue to the above-mentioned canvas."[39]

It would seem that before repainting the landscape Titian used an obliterating coat of paint, distinct from an intermediate varnish or oiling-out, only in selected areas,

and particularly under the sky in the top left hand corner. It is thin in places, in Sample E1 (Pl. 1b) a mere line of orange-brown between Titian's very thick ultramarine blue paint of the sky and the azurite layer beneath, but it does show fluorescence along this line. Under some of the clouds it is quite thick and has become conspicuous where they are thinly painted, and also worn. The rather drab pink of the cloud at the far left, although it may have been made more so by wearing, is actually intended, for it consists of a matrix of lead white in which there is a sparse scattering of ultramarine, azurite, red lake, black, and ochre particles. Pl. 6e is a photomicrograph of the top surface of Sample B6, *Dull pinkish cloud down left hand edge of picture, near top left corner*, before mounting and sectioning. Titian's orange-brown obliterating layer can be seen beneath, looking brighter and less brown under microscope illumination than it does on the picture. The cross section of the same sample (Pl. 6f) demonstrates how close to the picture surface the brown layer is at this point. A fluorescent line above the orange layer could be an intermediate varnish. There is much that cannot be understood in this region. For example, in this sample the orange layer looks double, and suspiciously like some of the double yellow granular layers encountered in a number of samples from lower down in the picture. Is it just possible that near the edges of the picture the painter of the intermediate landscape left a bit of his obliterating layer bare and Titian applied his over it?

Nor can any useful light be thrown on the problem of the nature and status of the architectural features that appear from the X-radiograph to be under the surface of the top left corner of the picture. One sample was possible, B8, *From pentimento of hidden buildings under pale blue cloud near left-hand edge of clump of trees.* In this sample there is on top of the white priming a trace of what looked like Bellini foliage on the right-hand side, then a warm yellow granular layer, again looking as if it were double, and above it a line of fluorescence that must signify the start of the Titian layers. This sample was looked at in the SEM and scanned by EDX layer by

layer. The yellow granular layer contained as principal elements lead and tin (with relatively low iron, and a little copper, probably from the green layer), and showed no difference in composition between the upper and lower part (indeed, the back-scattered image in the SEM suggested it was a single layer). The yellow granular layer in this case is therefore mainly lead-tin yellow and more like the yellow granular layers found in samples from lower down in the picture than the orange-brown ochre obscuring layer under Titian's thin clouds a little higher up on the left. Immediately on top of the yellow granular layer and the line of fluorescent material, and recognizable from its distinctive mixture of pigments, is the paint of the dull pink cloud (as in Sample B6, Pls. 6e, 6f), and finally a very thick creamy-white layer of lead white with a few ultramarine particles visible on the surface. This indicates that the hazy white form visible through the thin blue cloud at the location of sampling is not the pentimento of an architectural feature of the hidden intermediate landscape, as had been supposed, but a piece of white impasto very near the surface and on top of the Titian dull pinkish cloud.

The sorting out of superimposed layers is just as problematic with regard to the foliage. Comparison with photomicrographs of a number of paint cross sections made by Lazzarini[40] from well-documented works of Bellini, Titian, and other Venetian sixteenth-century painters proved less useful than hoped, since green colors had to be varied by ringing the changes with so small a range of pigments. David Bull noted below the level of what look like Titian leaves on the surface of the picture, in the area of the trees at the upper right, a whole area of a different type of leaf, each consisting of a rather uniform rounded blob of vivid grass-green. This vivid green color and the somewhat mechanical way of painting the leaves seemed to him rather like the painting of the newly-revealed bush between Pan and the nymph with the bowl, which he has very convincingly attributed to Dosso Dossi. SEM-EDX analysis was carried out on a sample of a little of the green from each

(Samples G4 and G5 respectively), but the principal elements in both were lead, copper, and tin, indicating mixtures of lead-tin yellow with green copper-based pigments, though the ratios were slightly different. Apart from rare novelties like the "green-red-and-blue" layer described above, the attribution of a particular type of green paint to a particular stage of painting, let alone a particular artist, seems unlikely. In the X-radiograph it is clear that many of the highlights seen on the foliage of the trees on the right are not of the leaves one sees on the picture surface, and even the contours of the masses of foliage are different, so that here also image-processing would be helpful. The painting includes yet another type of foliage, the golden-brown fernlike fronds at the top of the gigantic tree at the far right, and directly above the pheasant. These leaves, appear to be painted over and across the two types of leaves just described. Since the picture was cleaned these brown leaves look rather crude by comparison with the rest of the landscape and with foliage in other pictures by Titian, yet as David Bull has noted, they are present in early copies. A paint cross section of Sample B1, *Brown "Titian-type" leaves over Bellini tree trunk* (Pl. 6h), revealed two separate layers of Bellini tree trunk paint, presumably one a crossing branch, sandwiching a thick layer of green glaze, which must be Bellini foliage. On top is thick opaque yellow impasto of the leaf with a final glaze of yellow brown, and trace of old varnish. Between the upper Bellini tree trunk layer and the yellow impasto a line of fluorescence is seen when the sample is viewed under ultraviolet or blue visible light. This seems to make perfect sense, indicating Titian's intermediate varnish or oiling-out between his yellow impasto and the paint of the Bellini branch. The objection to this argument can be seen in that the yellow paint of the impasto runs down into a vertical crack in the Bellini layers beneath, implying that it was applied at a date late enough for age cracks in the paint to have formed. However, analysis of the yellow paint (by laser microspectral analysis) proved it to be lead-tin yellow. The pigment disappeared from use around the middle of the eighteenth century, and did not reappear until it was experimentally prepared in the twentieth. David Bull suggested Camuccini could have added or altered these brown leaves, using an old store of lead-tin yellow that he had in his studio. Or was there some reason for premature cracking of the paint before Titian came to add the yellow-brown leaves?

Investigation of the *Feast of the Gods* is by no means completed, even though the picture is now cleaned and restored. Further examination and analysis of existing samples and paint cross sections can be carried out by scanning electron microscope, energy dispersive X-ray fluorescence and laser microprobe analysis, as well as by some modern methods of microspectral analysis, not so far applied, which might amplify our knowledge of the pigments and clarify the significance of the unusual phenomenon of fluorescence between paint layers. Cleaning of the picture does not preclude, indeed aids, color measurements on the surface using modern reflectance spectrophotometry. Computer image processing applied to the X-radiographs, infrared photographs and reflectograms could serve to distinguish the various stages of painting, thereby providing information complementary to that derived from the samples and paint cross sections.

ACKNOWLEDGMENTS

I would like to thank the staff of the department of paintings conservation and the scientific department of the National Gallery of Art for their help and cooperation, particularly Barbara Berrie for carrying out X-ray diffraction and X-ray fluorescence analyses as well as undertaking much of the work of microscopy and photomicrography; former colleagues in the scientific department of the National Gallery, London: Raymond White for medium analysis, Ashok Roy for SEM/XRF and LMA analyses of pigments and paint cross sections, and Jo Kirby for help with references.

NOTES

1. See Appendix for a description of the apparatus and for the analytical results.

2. Helmut Ruhemann, "Criteria for distinguishing Additions from Original Paint," *Studies in Conservation* 3 (1958), 145–. An early and pioneering attempt to categorize the differences between original paint and repaint on pictures.

3. The technique of xeroradiography can to some extent separate the images of superimposed paint layers, but is likely to be superseded by image processing methods (the latter well-suited to the investigation of *The Feast of the Gods*). Autoradiography might be considered, but might not in the case of the landscape background of *The Feast of the Gods* produce clear results since in some areas there are superimposed layers (especially of green paint) of very similar chemical composition.

4. Joyce Plesters, "Titian's 'Bacchus and Ariadne', The Materials and Technique," *National Gallery Technical Bulletin* (London) 2 (1978), 38.

5. Lorenzo Lazzarini, "La Pala Barbarigo di Giovanni Bellini; Le analisi di Laboratorio," *Quaderni della Soprintendenza ai Beni Artistici e Storici di Venezia* 3 (1983), 23.

6. Madeleine Hours, "Contribution à l'étude de quelques oeuvres du Titien," *Annales, Laboratoire de Recherche des Musées de France* (1976), 7–30. In connection with the series of Bacchanals for Alfonso's *studiolo*, it is interesting to find that the series of paintings commissioned by his sister Isabella d'Este for her *studiolo* were all executed on a single type of canvas weave (see Sylvie Beguin, "L'analyse des peintures du 'Studiolo' d'Isabella d'Este au Laboratoire de Recherche des Musées de France, III, Commentaires," *Annales, Laboratoire de Recherche des Musées de France* (1975), 29.

7. Lorenzo Lazzarini, "La Pala Pesaro: Note Tech-niche," *Quaderni della Soprintendenza ai Beni Artistici e Storici di Venezia* 8 (1979), 68–71.

8. When making up canvases for large paintings the number of seams was generally kept to a minimum. The virtually square canvases of the two Prado Bacchanals and of *Bacchus and Ariadne* show the simplest solution, that of joining two loom widths along the selvedges to make a single central seam. An alternative often used in order to avoid a conspicuous central seam was to arrange the full loom width centrally on the stretcher, joined to a half loom width on either side. The assymetrically placed vertical seams of the canvas of *The Feast of the Gods* and the unusual mode of seaming might suggest that some experimenting was needed to find the right size and format.

9. See Rutherford J. Gettens, Hermann Kühn, and W.T. Chase, "Lead White," *Studies in Conservation* 12 (1967), 125–139, and Bernard Keisch, "X-ray Diffraction and the Composition of Lead White," *Studies in the History of Art*, National Gallery of Art, Washington (1972), 121–133. With regard to the occurrence of the normal lead carbonate in paintings, it must be remembered that in the past lead white has often been identified chemically without the aid of X-ray diffraction analysis to distinguish between the normal and basic forms of carbonate.

10. Lazzarini, "La Pala Barbarigo," 23.

11. Lorenzo Lazzarini, "Il Colore nei Pittori Veneziani tra il 1480 e il 1580," in *Studi Veneziani, Supplemento n.5 del Bollettino d'Arte* (1983), 138.

12. The present writer has detected in samples from paintings only one example of a mixture of basic and normal lead white in which the latter was in too high a concentration to be regarded as an impurity. The normal carbonate was detected in white impasto of the paint (not priming) of a Rubens (Joyce Plesters, " 'Samson and Delilah': Rubens and the Art and Craft of Painting on Panel," *National Gallery Technical Bulletin* [London], 7 [1983], 38).

13. H.W. Van Os, J.R.J. Van Asperen de Boer, C.E. De Jong-Jansen, and C. Wiethoff, eds., *The Early Venetian Paintings in Holland* (Maarssen, 1978), 32–38.

14. Lazzarini, "La Pala Barbarigo," 23.

15. Lazzarini, "Il Colore nei Pittori Veneziani," 139.

16. Lazzarini, "Il Colore nei Pittori Veneziani," 135–144

17. Because of the high price of the best blue pigments, ultramarine and azurite, attempts were constantly made from the late fourteenth century onward to manufacture cheaper imitations. Many early recipes for artificial azurite (blue verditer) are given by Mary P. Merrifield, *Original Treatises on the Arts of Painting*, 2 vols. (London, 1849). The recognition of the synthetic variety depends on the fact that under the microscope the pigment particles are small, rounded, and regular in size, whereas mineral azurite appears as broken crystalline fragments of irregular size and shape. Both natural and synthetic varieties have the same chemical composition

$(2CuCO_3.Cu(OH)_2)$ and refractive index and give identical X-ray diffraction patterns (R.J. Gettens and E.W. FitzHugh, "Azurite and Blue Verditer," *Studies in Conservation* 11 [1966], 54–61). Recently, however, it has been found that some early recipes result not in the basic carbonate, but in blue forms of copper acetate (Mary Virginia Orna, OSU, Manfred J.D. Low, and Maureen M. Julian, "Synthetic Blue Pigments: Ninth to Sixteenth Centuries. II. 'Silver Blue,'" *Studies in Conservation* 30 [1985], 155–160).

18. Despite the profusion of early recipes for the manufacture of artificial copper carbonate blues, the present author's own experience is that blue (as distinct from green) verditer is not commonly found in European easel paintings before the seventeenth century. Venetian painters in the sixteenth century, lacking ultramarine or azurite, tended to substitute smalt and indigo respectively. For preparation and use of blue verditer from the seventeenth century onward see R.D. Harley, *Artists' Pigments c.1600–1835*, 2d ed. (London, 1982), and P. and A. MacTaggart, "Refiners' Verditer," *Studies in Conservation* 25 [1980], 37-.

19. A description of the methods of analysis used for the paint media is given by John S. Mills and Raymond White, *The Organic Chemistry of Museum Objects* (London, 1987), 141–148.

20. Mills and White 1987, 144–146, describe the identification of traces of surviving components of pine resin in samples of well-preserved copper resinate green glazes from paintings by Raphael, Altdorfer, Veronese, and Rubens.

21. A clear account of the possibilities and limitations of staining methods for identification of paint media is given by M.-C. Gay, "Application of the Staining Method to Cross Sections in the Study of Various Italian Paintings of the Fourteenth and Fifteenth Centuries," in *Conservation and Restoration of Pictorial Art*, eds. N. Brommelle and P. Smith, (London, 1976), 78–83.

22. Mills and White collated the palmitate/stearate ratios obtained from medium analyses carried out over a period of years in the National Gallery, London, on samples from Italian paintings and plotted them in the form of a histogram. From the limited data available it could be deduced that walnut oil predominated before 1520, linseed oil after that date.

23. It should be possible to identify the red lake pigment in the paint section from Sample FII, *Pink of Cybele's dress*, using a modern microspectrophotometric method. Also, techniques of reflectance spectrophotometry on the surface of the picture itself have now become so accurate and sensitive as to enable lake pigments to be identified by this non-sampling technique, so that identification of the red lake pigments that occurs on *The Feast of the Gods* is not ruled out. A variety of insect and plant dyestuffs—kermes, lac, brazilwood, and madder being the principal ones (see Jo Kirby, "A Spectrophotometric Method for the Identification of Lake Pigment Dyestuffs," *National Gallery Technical Bulletin* 1 [1977], 35–48)—were used in sixteenth-century Venetian painting. Furthermore, during the period between

Bellini completing his work on *The Feast of the Gods* and Titian finishing his, a further dyestuff for red lake pigments was introduced into Europe with the discovery of the New World. This was cochineal, first brought to Europe about 1523 and at once adopted for use (see Helmut Schweppe and Heinz Roosen-Runge, "Carmine—Cochineal Carmine and Kermes Carmine," in *Artists' Pigments, A Handbook of their History and Characteristics*, ed. Robert L. Feller [Washington and Cambridge, 1986], 255–283).

24. The earliest Venetian picture in which realgar has been identified in the National Gallery, London, is Cima's *Incredulity of Saint Thomas* (Jill Dunkerton and Ashok Roy, "The Technique and Restoration of Cima's 'The Incredulity of S. Thomas,'" *National Gallery Technical Bulletin* [London] 10 [1986], 4–27), but Lazzarini has noted it in a Cima of 1496. Lazzarini found both realgar and orpiment in Bellini's *Saint Giovanni Crisostomo Altarpiece* of 1513 but not in the earlier *Barbarigo Altarpiece* of 1488. The association of realgar with Venetian painting was recognized early on. Lomazzo, referring to realgar as "burnt orpiment" (an artificial variety can be made by roasting orpiment) remarks that it is "the color of gold, and this is the alchemy of the Venetian painters" (G.P. Lomazzo, *Trattato dell'Arte de la Pittura* [Milan, 1584], 191).

25. See Appendix for X-ray fluorescence analysis data.

26. Unlike Bellini, who left his figures in reserve while painting the background then painted the flesh very thinly so that the figures appear as black silhouettes on the X-radiograph, Titian regularly underpaints all flesh with a solid opaque underpaint containing a high proportion of lead white, regardless of the final flesh tint at the surface. As a result the flesh paint in Titian's paintings appears as dense white patches on the X-radiographs. In *Bacchus and Ariadne* the flesh of the dark-skinned satyrs appears not much less dense on the X-radiograph than that of the fairer-skinned Bacchantes or of Bacchus and Ariadne. For further examples of opaque flesh paint in Titian's pictures see Hours 1976, 7–30.

27. Allan Braham, Martin Wyld, and Joyce Plesters, "Bellini's 'The Blood of the Redeeemer',' *National Gallery Technical Bulletin* (London) 2 (1978), 11–24.

28. Dunkerton and Roy 1986, 18. The present writer has encountered a rather similar mixture containing vermilion, black, and lead white in two paintings by Rogier van der Weyden in the National Gallery, London. In the first, *The Magdalen Reading*, it constitutes the brown paint of the Gothic cupboard behind the Magdalen, in the second, *Saint Ivo*, it is the brown paint of the window shutter.

29. Visible light fluorescence microscopy was carried out using a Leitz Ploemopak. The Ploemopak allows fluorescence microscopy through incident-light excitation. Radiation emitted by the light source (that is, a xenon lamp) passes through a filter block consisting of an exciting filter, dichroic beam splitter, and a long-pass suppression filter. Light first passes through the exciting filter and becomes incident in a

dichroic beam splitter. It is then deflected to the objective, which concentrates the exciting radiation onto the specimen (that is, a cross section). Fluorescent light emitted by the specimen is collected by the objective, and travels in the opposite direction up to the dichroic beam splitter, which directs it to the eyepiece through the suppression filter. Blocks are selected by the microscopist to meet particular excitation range requirements. The Ploemopak accepts up to four filter blocks simultaneously. NGA filter block combination consists of Leitz filter blocks A, B, I2, and M2, which excite in the u.v., u.v. + violet, blue, and green ranges respectively. Filter block I2 is the most frequently used in this study.

30. E. René de la Rie, "Fluorescence of Paint and Varnish Layers," Parts I–III, *Studies in Conservation* 27 (1982), 1–7, 65–69 and 102–108.

31. De la Rie (1982, Part III, 102) has also noted that when mixed with oil both lead white and ultramarine fluoresce under ultraviolet (or other fluorescing conditions), the former bluish-white and the latter blue. This phenomenon can be seen in paint cross sections from *The Feast of the Gods* in which either of these pigments occurs, but is readily distinguishable from the thin lines of yellow fluorescence between certain paint layers.

32. De la Rie 1982, Part III, 102.

33. See Appendix for analytical data.

34. Armenini gives instructions for "oiling-out" the surface of paintings, particularly before applying final glazes (Giovanni Battista Armenini, *De' veri Precetti della Pittura* (Ravenna, 1586).

35. There seems to be little documentary evidence to indicate the use of a retouching varnish (as an alternative to oiling-out) before the eighteenth century.

36. Allan Braham and Jill Dunkerton, "Fragments of a Ceiling Decoration by Dosso Dossi," *National Gallery Technical Bulletin* (London) 5 (1981), 26–37. X-radiographs show that Dosso Dossi sometimes reused his canvases for a different composition (see A. Mezzetti, *Il Dosso e Battista Ferraresi* [Milan, 1965], which would indicate that he had some experience of painting on top of a finished composition, a process that might involve oiling out or the application of an intermediate varnish.

37. A similar example of an early restorer removing original paint in order to explore beneath the paint surface was noted when Titian's *Portrait of a Lady (La Schiavona)* was cleaned in 1959. Among several *pentimenti* visible in the X-radiograph was what may have been intended as a roundel window with a view of clouds beneath the black background at upper right. On removal of resinous overpaint from the area it was discovered that an earlier restorer had scraped off all but traces of Titian's original black paint of the background in that area only to find that the hidden feature was in an unfinished state. He must then have covered it up again, matching his own resinous black overpaint to Titian's original black background. See Cecil Gould, *National Gallery Catalogues: The Sixteenth-Century Italian Schools* (London, 1975), 287–289.

38. The greens in the Cima *Incredulity of Saint Thomas* were found to have a very complex multi-layer structure (Dunkerton and Roy 1986, 12–13 and 15–16). Some sections showed an intermediate layer of red lake glaze sandwiched between green. Like the green-blue-red layer that occurs in some samples from the middle distant landscape of *The Feast of the Gods*, it may represent an attempt to extend the range of shades of green available, in this case using an optical mixture of superimposed semitransparent layers rather than a physical mixture of different colored pigments ground together, the latter always tending toward grayish and dullish.

39. Dana Goodgal, "The Camerino of Alfonso I d'Este," *Art History* 2 (1978), 185 and n. 67.

40. Lorenzo Lazzarini, "Lo Studio stratigrafico della Pala di Castelfranco e di altre Opere contemporanee," in *Giorgione—la Pala di Castelfranco Veneto* [exh. cat. by L. Lazzarini, F. Pedrocco, T. Pignatti, P. Spezzani, and F. Valcanover] (Castelfranco Veneto, 1978), 45–58.

APPENDIX A

Summary of Results of EDX Analysis of The Feast of the Gods

The elemental composition of certain areas of the painting was obtained in order to try to determine the palette used. The results obtained this way corroborate identifications made by examining the surface of the painting and cross sections. The instrumentation used was the Kevex 0750A, which is designed for examining objects in air—no samples were taken. Elements lighter than calcium cannot be detected. Spectra A–S were obtained using molybdenum as the secondary target and T–X using barium chloride. In many instances, the presence of lead in the spectrum is due to the white priming and calcium to the gesso. Quantitative data are not obtained by this analysis, however, qualitative judgments concerning relative amounts may be made. The letters after the elemental symbols denote respectively: vs—very strong, s—strong, m—medium, w—weak, vw—very weak.

Area examined	Elements found	Interpretation
A. Silenus' orange robe	$Pb(s)$, $As(m)$, $Fe(m)$, $Cu(w)$, $Ca(w)$, $Zn(vw)$	The orange is likely to be orpiment and/or realgar and confirms the observation of orpiment crystals on the surface of the painting. The lead probably arises from the priming and calcium from the gesso ground.
B. Jupiter's scarlet robe	$Pb(s)$, $Hg(s)$, $Fe(vw)$, $Zn(vw)$	Confirms identification of opaque red pigment as vermilion.
C. Jupiter's yellow- and blue-shot sleeve	$Pb(vs)$, $Fe(vw)$	No tin detected using Mo target; but possibly lead-tin yellow.
D. Jupiter's sleeve, blue shadow	$Pb(vs)$, $Fe(vw)$, no Cu	Since Cu is absent, the blue cannot be azurite.
E. Jupiter's eagle, body	$Pb(s)$, $Cu(w)$, no Fe or Ca detected	The thin paint may be a carbon black.
F. Jupiter's eagle, neck	$Pb(s)$, $Cu(w)$	As E.

G. Blue design in bowl held by nymph	Cu(vs), Pb(m), Fe(w)	Corroborates the identification of azurite.
H. Nymph's orange robe, shadow	Pb(vs), Hg(vw), no As	The orange may be composed of lead-tin yellow and vermilion; use of a red lake cannot be ruled out.
I. Nymph's orange robe, highlight	Pb(s), Hg(vw), no As	The orange is not orpiment. It is probably a mixture of lead-tin yellow and vermilion.
J. Pan's chest	Pb(s), Hg(m), Ca(vw), Fe(vw), Cu(vw)	The brown may comprise carbon black and vermilion, rather than iron earths (this is confirmed in cross section F30, Pl. 3a).
K. Satyr with bowl, chest	Pb(s), Hg(m), Fe(m), no Ca	As J.
L. Mercury's right cheek	Pb(s), Hg(m), Fe(vw), Cu(vw), no Ca	The pink flesh comprises lead white and vermilion.
M. Cybele's right cheek	Pb(s), Hg(m), Fe(vw), Cu(vw), no Ca	As L.
N. Lotis' left cheek	Pb(s), Hg(m), no Fe, Cu, Zn	As L but with a lower proportion of Hg and therefore vermilion.
O. Lotis' left breast	Pb(s), Hg(m), no Zn, Cu, Fe	This spectrum was identical to N.
P. Nymph with orange robe, right cheek	Pb(s), Hg(m), Fe(vw)	This flesh is very similar to the gods' flesh.
Q. Nymph with orange robe, right breast	Pb(s), Hg(m), Cu(vw), Zn(vw), no Fe	As P.
R. Priapus' cloak, red area of changing drapery	Pb(s), Cu(s), Hg(m), no Ca	Vermilion is present (there is also probably a lake accounting for the deep red color); the copper is probably from adjacent green shadows.
S. Priapus' cloak, green shadow	Cu(vs), Pb(s), Fe(vw), no Hg, Ca	The green must be a copper pigment, probably verdigris.
T. Green landscape (lime-green)	Pb(s), Cu(m), Sn(w)	The green comprises lead white, lead-tin yellow (identified as type I using XRD), and a copper-green.
U. Green landscape, beside Apollo's lyre	Cu(vs), Pb(s), Sn(w)	Similar to S, although containing more copper.

V. Light green foreground, between Mercury's feet	Pb(vs), Cu(s), Sn(m)	Lead-tin yellow and a copper green are present. This area of landscape has the largest content of tin and is the palest green.
W. Landscape, lower left	Pb(s), Cu(m), Sn(w), Ca(vw)	Similar to V.
X. Brown leaf painted directly on the sky between the tree trunks above Priapus' head	Pb(vs), Cu(vs), Fe(vw)	In the absence of iron as a major element, an iron ochre pigment does not provide the brown color.

Gas Chromatograms after Removal of Repaint

M1

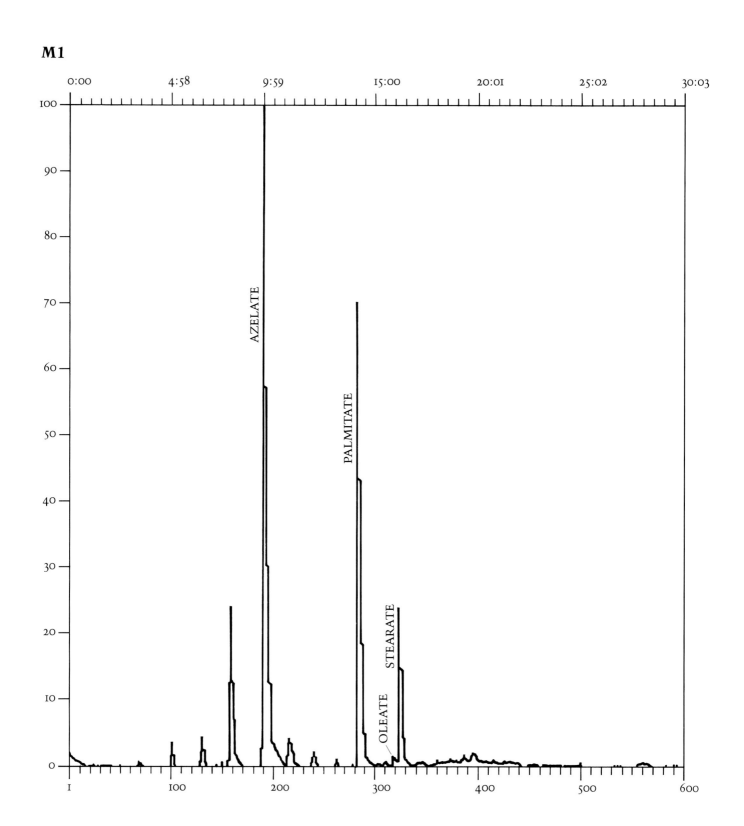

The chromatograms were run by R. White at the National Gallery, London. The ratios of methyl palmitate to stearate are $M_1 = 3.8$; $M_4 = 2.8$; $M_6 = 3.2$. These all suggest walnut oil was the paint medium. From GC/MS examination M_5 is a mixture of egg and oil.

Relative amount is indicated on the vertical axis. Time, in minutes, is given along the top and scan number along the bottom.

M4

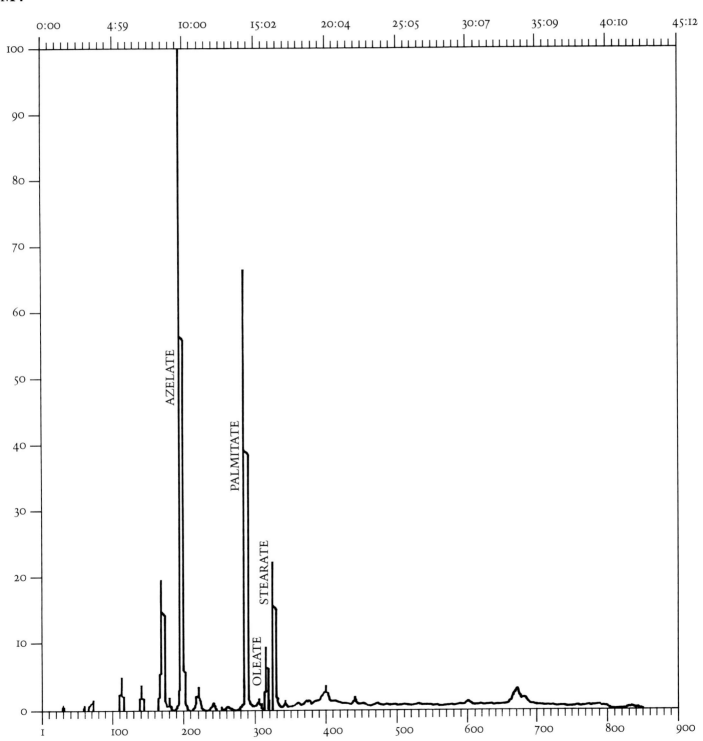

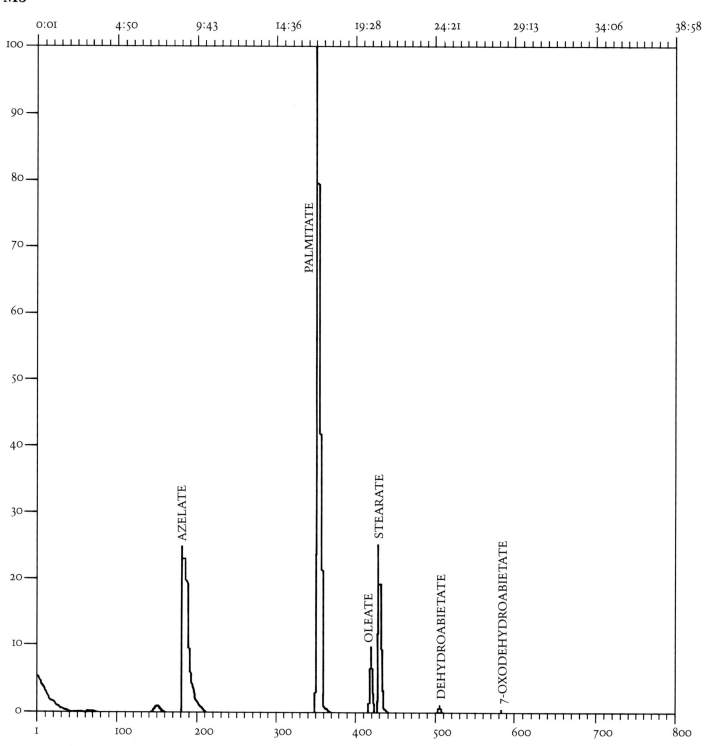

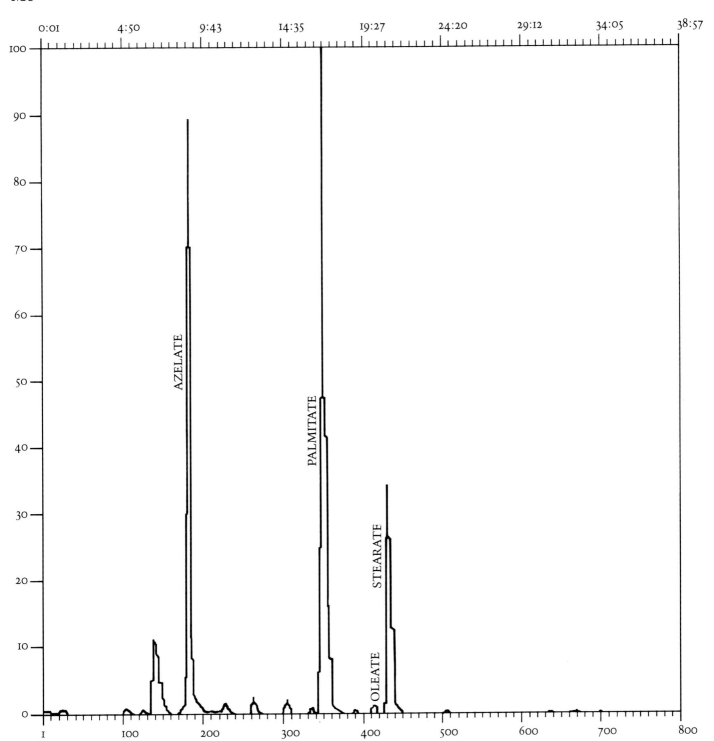

APPENDIX C

X-Ray Diffraction Data

The X-ray diffraction patterns were obtained on film strips in Gandolfi cameras. A Philips XRG 3100 X-ray generator with a copper anode tube and a nickel filter was used. Interplanar spacings, d (given in Å), were measured from the film strip using a calibrated rule and relative intensities of the lines in a pattern estimated by eye. The results for samples are given below with matches found by searching the JCPDS files (JCPDS International Centre for Diffraction Data, Swarthmore, Pennsylvania, 1982).

TABLE 1. d-spacings and relative intensities of lines in a sample from the paint in the green Bellini foreground showing the presence of lead white ($2PbCO_3.Pb(OH)_2$) and lead-tin yellow (Pb_2SnO_4)

yellow-green sward		Pb_2SnO_4 24–589		$2PbCO_3.Pb(OH)_2$ 13–131	
d,Å	I	d,Å	I	d,Å	I
6.1		6.18	1		
4.50				4.47	60
4.30		4.37	<1	4.25	60
3.61		3.59	2	3.61	90
3.35	100	3.32	100		
3.29				3.29	90
3.10		3.15	9		
2.83		2.80	20		
2.78		2.76	30		
				2.71	20
2.67	30			2.62	100
2.58		2.56	14		
2.49	5			2.49	30
2.48	10				
2.43	10				
2.36	12				
				2.23	50
2.12	5			2.12	20
2.06	10			2.05	30
2.00	10				
1.85	60	1.85	16	1.88	20
				1.86	30
1.79	50	1.79	14		
1.76	15				
1.72	60	1.72	17	1.70	40
				1.65	20
1.56	40	1.57	11	1.58	20

TABLE 2. d-spacings and relative intensities of white priming showing the presence of both basic lead carbonate and normal lead carbonate

white priming		$PbCO_3$ 5–417		$2PbCO_3 \cdot Pb(OH)_2$ 13–131	
4.45	40			4.47	60
4.25	40	4.23	17	4.25	60
3.60	100	3.59	100	3.61	90
3.50	50	3.50	43		
3.29	60			3.29	90
3.08	10	3.08	24		
				2.71	20
2.65	60	2.64	2	2.62	100
		2.59	11		
2.49	50	2.49	32	2.49	30
				2.26	10
2.24	20			2.23	50
2.13	5			2.12	30
2.08	5	2.08	27	2.10	20
2.05	10			2.05	30
1.99	5	2.01	11		
		1.98	9		
1.94	5				
1.86	30	1.86	20	1.88	20
1.79	5				
1.70	20			1.70	40
1.59	10			1.58	20

TABLE 3. d-spacings and relative intensities for brown leaves at top right corner showing the paint contains lead-tin yellow and for the white paint of Bacchus' sleeve showing it contains lead white

brown leaves		Pb_2SnO_4 24–589		Bacchus' white sleeve		$2PbCO_3 \cdot Pb(OH)_2$ 13–131	
3.61	5	3.59	2	4.49	40	4.49	60
3.32	100	3.32	100	4.24	40	4.25	60
3.18	10	3.15	9	3.61	100	3.61	100
3.10	10	3.15	9	3.50	10		
2.83	90	2.80	20	3.29	100	3.29	100
2.77	50	2.76	30	2.72	5	2.71	20
2.65	20			2.62	85	2.62	100
2.55	20	2.56	14	2.49	15	2.49	30
1.99	60			2.24	20	2.23	50
1.85	10	1.85	16	2.12	10	2.12	20
1.79	20	1.79	14	2.11	10		
1.76	15			2.15	15	2.05	30
1.72	25	1.77	17	1.89	5	1.88	20
1.63	15			1.86	15	1.86	30
1.57	10	1.57	11	1.70	10	1.70	40
				1.65	20		
				1.58	20	1.58	20

The Feast of the Gods:
A Bibliography

Battisti, Eugenio. "Disegni inediti di Tiziano e lo Studio d'Alfonso d'Este." *Commentari* 5 (1954), 191-216.

Battisti, Eugenio. "Mitologie per Alfonso d'Este." *Rinascimento e Barocco* (1960), 112-145.

Bertos, Rigas N. "Some Remarks on Titian and Bellini at Ferrara." *RACAR* 2 (1975), 49-54.

Bonicatti, Maurizio. *Aspetti dell'umanesimo nella pittura veneta dal 1455 al 1515.* Rome, 1964.

Boschini, Marco. *La carta del navegar pitoresco.* Venice, 1660.

Campori, Giuseppe. "Tiziano e gli Estensi." *Nuova Antologia di Scienze, lettere ed arti* 27 (1874), 586-587.

Cavalli-Bjorkman, Gorel, ed. *Bacchanals by Titian and Rubens.* Stockholm, 1987.

Cavalli-Bjorkman, Gorel. "Camerino D'Alabastro: A Renaissance Room in Ferrara." *Nationalmuseum Bulletin* 11, no. 2 (1987), 69-90.

Cittadella, Luigi Napoleone. *Documenti ed illustrazioni: risquardanti la storia artistica ferrarese.* Ferrara, 1868.

Fehl, Philipp. "The Worship of Bacchus and Venus in Bellini's and Titian's Bacchanals for Alfonso d'Este." *Studies in the History of Art* 6 (1974), 37-95.

Gibbons, Felton Lewis. *Dossi and Battista Dossi: Court Painters at Ferrara.* Princeton, 1968.

Goodgal, Dana. "The Camerino of Alfonso d'Este." *Art History* 1 (1978), 162-190.

Gould, Cecil. *Studio of Alfonso d'Este and Titian's Bacchus and Ariadne.* London, 1969.

Hadley, Rollin van. *The Letters of Bernard Berenson and Isabella Stewart Gardner.* Boston, 1987.

Hope, Charles. "The Camerini d'Alabastra of Alfonso Este." *Burlington Magazine* 113 (November 1971), 641-650, 712-721.

Mezzetti, Amalia. "Le Storie di Enea del Dosso nel Camerino d'Alabastro di Alfonso I d'Este." *Paragone* 189 (1965), 71-84.

———. "Un inedito del Dosso e qualche precisazione." *Paragone* 303 (1975), 11-21.

National Gallery of Art. *Catalogue of the Italian Paintings.* Washington, 1979, 38-47.

Ovid. *Fasti.* Translation by Sir James George Frazer. Loeb Classical Library. London and New York, 1931.

Planiscig, Leo. *Venezianische Bildhauer der Renaissance.* Vienna, 1921.

Ridolfi, Carlo. *Le maraviglie dell'arte, ouero Le vite de gl'illustri pittori veneti, e dello stato.* Venice, 1648.

Shearman, John. "Alfonso d'Este's Camerino." (forthcoming in Festschrift for André Chastel).

Spitzer, Frederic. *La collection Spitzer.* Paris, 1890-1892.

Vasari, Giorgio. *Le vite de piu eccellenti pittori, scultori ed architettori.* Florence, 1878-1885.

Venturi, Adolfo. *Storia dell'arte italiana.* Milan, 1901-1940.

———. *La R. Galleria Estense in Modena.* Modena, 1882.

Walker, John. *Bellini and Titian at Ferrara: a Study of Styles and Taste.* London, 1966.

Wethey, Harold. *Titian: the Mythological and Historical Paintings.* London, 1975.

Wilde, Johannes. *Venetian Art from Bellini to Titian.* Oxford, 1974.

Wind, Edgar. *Bellini's Feast of the Gods: A Study in Venetian Humanism.* Cambridge, Mass., 1948.

Winternitz, Emmanuel. "A lira da braccio in Giovanni Bellini's Feast of the Gods." *Art Bulletin* 28 (1946), 114-115.

Compiled by Lamia Doumato
Head of Reader Services
National Gallery of Art Library